SCARED!

HOW TO DRAW FANTASTIC HORROR COMIC CHARACTERS

STEVE MILLER AND BRYAN BAUGH

Watson-Guptill Publications
New York

Senior editor: Candace Raney
Editor: Sylvia Warren
Senior Production manager: Ellen Greene
Designer: Jay Anning, Thumb Print

© 2004 by Steve Miller and Bryan Baugh

ISBN: 0-8230-1664-1

First published in 2004 by Watson-Guptill Publications,
a division of VNU Business Media, Inc.
770 Broadway, New York, N.Y.
www.wgpub.com

Library of Congress Control Number: 2004112245

Printed in the United States
First printing, 2004

2 3 4 5 6 7 8 9 / 10 09 08 07 06 05

Dedications

This book is dedicated to my sister, Carrie, and my brother, Craig, who grew up with the most horrific creature imaginable, a middle sibling.

—STEVE MILLER

This book is dedicated to every kid who ever got in trouble for drawing monsters when he was supposed to be paying attention in school.

—BRYAN BAUGH

Special words of thanks are due to Bernie Wrightson for being such a lifelong inspiration to both of us as artists and for his generous contribution to this book.

—BRYAN BAUGH and STEVE MILLER

CONTENTS

BAUGH '04

About the Artists

Arthur Adams has been involved in the comics industry since the early eighties. Arthur combines a dynamic, lively, and often humorous style with well-planned layouts and incredible attention to detail. His credits are legion. Suffice it to say that he has worked for every major comic book publisher in America. Adams's fan base is so well established that he is considered the first choice whenever a cover artist is needed to help attract readers to a new series. Visit his website at http://home.pacbell.net/adbm3/ArtAdams.htm

Darryl Banks, who did the steps for Vincent Locke's Phantom of the Opera and Frank Cho's Kong vs. T-Rex, graduated from and taught illustration at the Columbus College of Art and Design. He worked for various independent comic companies before starting a seven-year run on DC Comics, *Green Lantern* where he co-created the popular New Green Lantern and Parallax characters.

Bryan Baugh regularly works as a storyboard artist for animated television shows. His credits include *Batman, Jackie Chan Adventures, Roughnecks: The Starship Troopers Chronicles, Men in Black, Masters of the Universe*, and several others. He has also contributed artwork to children's books and magazines. Baugh currently writes and illustrates his horror comic book, *Wulf and Batsy*, for Chanting Monks Studios. He grew up in Fairborn, Ohio, but now lives in Thousand Oaks, California, with his green-eyed goth-queen wife Monica and two ferocious jungle cats, Lucy and Tiger. You can see more of Bryan's artwork at his website, http://www.cryptlogic.net.

Brett Booth wrote and penciled Wildstorm Productions' *Kindred, Backlash, Wildcore*, and *Backlash/Spider-Man* comic books. At Marvel Comics he penciled *Heroes Reborn: Fantastic Four, X-Men Unlimited*, and *X-Men*.

Bill Bronson has worked as a toy designer for Trendmaster Toys in St. Louis, Missouri, and is the mad genius behind the book *Chicks and Monsters*. He helped us out on *Scared!* by drawing many of the animals in the "Creature Features" section. Bronson describes himself as "a Midwestern sci-fi and horror illustrator who has recently relocated to the West Coast." More of his work can be seen at the Ravenous Media website, http://www.ravenousmedia.com/profile.php?u=williamsquid.

Mitch Byrd's work is fiendishly clever, and he has long been a fan favorite. Byrd has worked for Dark Horse, Verotik, and DC Comics, and he has devoted a lot of time to raising up the next generation of artists by doing numerous how-to-draw books and articles.

Frank Cho is the creator of the popular syndicated comic strip *Liberty Meadows*, which appears daily in newspapers and in an unexpurgated form from Image Comics. Cho effortlessly combines the classic illustration disciplines used to create action comic strips for the newspapers with the timing and humor of a master gag artist.

Roger Cruz is a widely-sought-after artist in both the United States and his native Brazil. His work combines elements of Manga style with a strong sense of design and atmosphere. He has worked for Marvel, DC, and Image Comics on popular characters from the *X-Men* and the *Batman* lines. Check out his website at http://www.rogercruz.com.br/#

Vincent Locke, one of the top horror artists working in comics and illustration today, broke onto the independent comic scene in the late eighties with his ghastly creation *Deadworld*, a black-and-white comic set in a future in which a majority of the Earth's population have become zombies. Since then he has done some frightful work for DC Comic's Vertigo imprint, Moonstone, White Wolf, and various RPGs and album covers. Website: http://www.vincelocke.com

Steve Miller is an author and artist who has worked in numerous areas of the entertainment field. His drawings have been used in the production of videos, toys, RPGs, and video games. Steve's latest book is *Freaks! How to Draw Fantastic Fantasy Creatures*. He lives in Ohio with his lovely wife and two wonderful kids. Visit his website at http://www.illustratorx.com.

Al Rio is an accomplished comic and fantasy artist living in Fortaleza-Ceará Brazil. He has worked on such high-profile comic books as *Gen 13* and *DV8* for Image Comics, as well as numerous titles for both Marvel and DC Comics. To see more of Al's work, visit http://www.alrioart.com.

Bernie Wrightson, widely known as "The Master of the Macabre," needs no introduction. The legendary Wrightson has illustrated the works of Stephen King, Edgar Allan Poe, H. P. Lovecraft, and Mary Wollstonecraft Shelley. His comic book credits include *Swamp Thing, Creepshow, House of Mystery, House of Secrets, Creepy, Eerie, Twisted Tales*, and countless others. He currently resides in Southern California. Bernie's website is http://www.berniewrightson.com.

Steve Miller was the colorist for most of the creepy characters in *Scared!*

INTRODUCTION

There are many good books out there that can tell you how to create dynamic superhero comics. They tell you to use dramatic camera angles in every panel and exaggerate your characters' poses so they evoke a feeling of urgency and dynamism. I agree with all those points. But drawing a horror comic book is not the same as drawing a superhero or action comic book. When drawing horror comics, keep in mind that the main goal is not to create a sense of extreme action. The goal is to freak out the reader. So a somewhat different bag of tricks is required for the job. When drawing a horror comic, you must create an atmosphere of weird, demented creepiness that runs throughout the story. You don't actually have to be a weird, demented person to do this effectively. But I won't lie to you, it helps.

Before you can do good work in any genre, you've got to immerse yourself in that genre. If you want to draw science fiction stories, you need to be looking at a lot of science fiction and fantasy material. If you want to draw Westerns, you need to be reading books about the Old West and watching cowboy movies. Same thing goes with horror. In order to be a solid horror illustrator, you have to develop a solid relationship with horror. You have to learn to speak its language. So if you want to draw horror comics, start looking at lots of horror comics. See what the professional artists out there are doing. But whatever you do, don't limit yourself by only having eyes for the latest stuff. I'm not knocking today's horror comics, not by any stretch of the imagination, because there is good material coming out now. But it would be foolish for a young artist to forget that the comic book art form was born in the 1890s, so no matter who your favorite new comic book artists are, there are over one hundred years worth of great comic art behind them.

So, sure, explore the work of your most recent artistic heroes to your heart's content. Just don't cheat yourself by stopping there. That will only turn you into an imitator. There are too many people doing that already. And in the world of art, nothing is more boring than imitation. That is one thing that has always been damaging to the comic book medium. An artist with an exciting new drawing style will come along and start being praised as the latest "hot artist." And you know what happens next. Immediately a dozen other companies start paying second-rate hacks to do their second-rate imitations of that artist. Well, if that's the only way you can find work in comics, okay, I guess you do what you have to do. But think about it: Who do you want to be, the latest big artist on the scene or the guy who can only make a living by imitating the latest big artist?

Broaden your scope. Find and learn from the great comic book artists of the past, people your friends may be skipping over. The next time you visit your local comic book store, don't just scan the shelves for the latest issue of your favorite comic. Instead, try looking in the dusty old back-issue bins and see if you can dig up copies of some of the older classic horror comics. You may find something that was printed fifteen years before you were born that contains artwork far scarier than any of the newer, computer-colored, slicko comics coming out these days. How do you know what old, out-of-print titles to go hunting for? The first chapter in this book, "A Brief History of Horror," will certainly give you some ideas.

To develop a full understanding of your chosen field—in this case horror comic illustration—you'll need to go beyond the comic book medium. Go back and read, or reread, the great horror authors. Study the films. Personally, nothing fires me up to draw my monsters quicker than going back and watching my favorite horror flicks. (My favorites will probably be different from yours, but that's fine, that's why no two artists are the same.) So go to lots of scary movies, look at lots of horror art, and read lots of horror stories.

And learn to speak the language of horror.

—BRYAN BAUGH

The Birth of a Genre

Illustrated horror was born in the late 1700s.

It all started in 1765 with the publication of Horace Walpole's *The Castle of Otranto*, the first of a genre that has endured, in various incarnations, over the centuries: the Gothic tale. By the end of the century, Gothic novels had become immensely popular. They were, however, expensive, putting them beyond the reach of the average reader.

A few publishers—recognizing a money-making opportunity—started to print popular Gothic novels in slender stitched booklets one chapter at a time, leaving readers hanging. If you liked how the story was going, you could buy the following volume to find out what happened next. But something was missing, the hook that would grab readers' attention and guarantee that these things would fly off the shelves. So publishers adapted the *chapbook* format for their tales of mystery and horror, hiring artists to create lurid illustrations that could be put in every few pages or so, depicting the strange events in the story. The price—one shilling—was right, and by the early 1800s, these "shilling shockers" were far and away the most popular form of fiction.

As more publishers embraced this storytelling format, competition for reader attention intensified. There wasn't much gold left to be mined from full-length Gothic novels, and publishers hired writers to come up with original plotlines. Subject matter quickly shifted from relatively tame stories of haunted manor houses to grisly tales of torture, murder, and the occult. This new breed of shilling shocker soon earned a new nickname: "penny dreadfuls." (Sweeney Todd, the Demon Barber, made his first appearance in a penny dreadful.)

Libraries these days offer far more than just books. You can check out CDs, art prints, movies, software, books on tape . . . and you might even find a branch that offers a gateway to another dimension. Just be careful what doors you open; they are not always so easy to close. Here Vince Locke has used a powerful bird's-eye-view perspective to increase the visual impact of the illustration. The lighting—top, light objects on dark background; bottom, dark objects on a light background—keeps the focus where the artist wants it.

Cruz Classic Monsters

Dracula, Frankenstein's Monster, and the Wolfman, from the inimitable imagination of Roger Cruz.

©2004 Vincent Locke

©2004 Roger Cruz

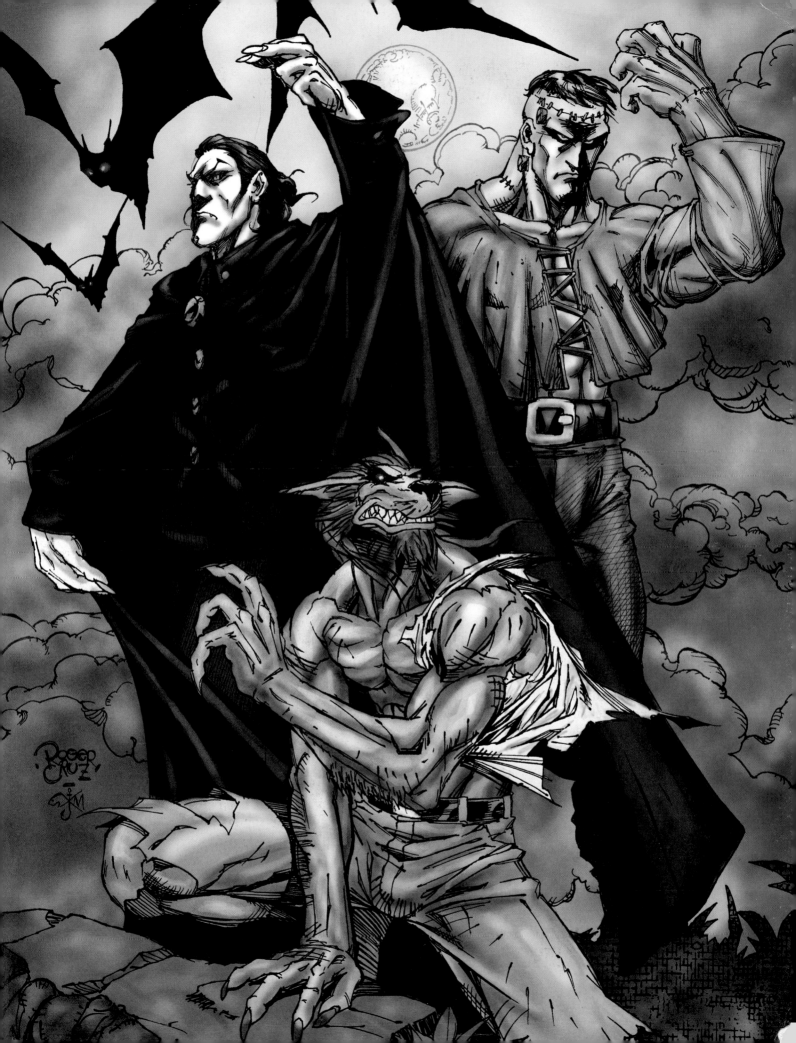

While the writing in the penny dreadfuls was often hackwork, most of the artwork was actually quite good. It had to be. A decent illustration of a beautiful young girl being attacked in her bedroom by a slouching killer with a knife was the sort of thing that could convince potential buyers to spend those pennies before they even knew what the story was about.

Well-known artists such as Henry Anelay (1858–1873) and Mary Byfield were drafted to develop the look of the penny dreadfuls, along with countless others who left their work anonymous! Usually working in woodcuts or steel engravings, these illustrators depicted a black-and-white world of horror and graphic violence. The figures were always posed theatrically. The backgrounds, while mostly shown in flat perspective, were often heavily detailed. As these illustrated fiction magazines became even more popular in the latter half of the nineteenth century, production values went up. More expensive, slicker papers were used, raising the cover price to a nickel, then to a dime, then to the princely sum of 50 cents.

The Pulps

American publisher Frank A. Munsey (1854–1925) found that by printing on rough wood pulp paper, he could publish exactly the same type of magazine at a lower cover price and outsell the competition. In October 1896, Munsey did just that. He came out with the first issue of *Argosy* magazine, and revolutionized the industry.

Almost immediately other publishers of illustrated fiction began copying Munsey's strategy. The "pulps" covered all genres, but for the first two decades of the 20th century most of them dealt with crime, science fiction, and the Wild West. In 1923, the first issue of *Weird Tales*, a pulp fiction magazine dedicated specifically to fantasy and horror, hit the stands. The cover shows a woman being attacked by a slimy creature with giant tentacles; her only defender is a wild-eyed man with a knife.

Many writers who are today considered masters of horror and supernatural fiction got their start in the pages of *Weird Tales*, including H. P. Lovecraft, Ray Bradbury, R. E. Howard, Clark Ashton Smith, and Robert Bloch. Illustrators for the magazine included that master of detailed fantasy/horror, Virgil Finlay, and Margaret Brundage, who used her daughters as models for the nude and seminude damsels in danger on *Weird Tales* covers.

But it was the ingeniously bizarre Lee Brown Coye (1907–1981) who happily pushed realism aside in favor of a twisted, creepy surrealism which resulted in some of *Weird Tales'* most effective imagery and would influence the look of horror comic books a couple of decades down the road. Coye's distinctive style resembled that of a 19th-century penny dreadful illustrator gone stark, raving mad. His figures had the appearance of tortured arthritics with bad joints or liquid people with no bones in their bodies; they either cringe and clench or sway loosely in the wind like ghosts. By this time, comic books were around but still in their infancy, and mostly aimed at children. They consisted mainly of superheroes and funny animal stories. It would be a few more years before the monsters, zombies, and murderers who figured so largely in the horror pulps finally clawed their way into the comics.

Up From the Grave
Wide awake and looking for humans to eat!

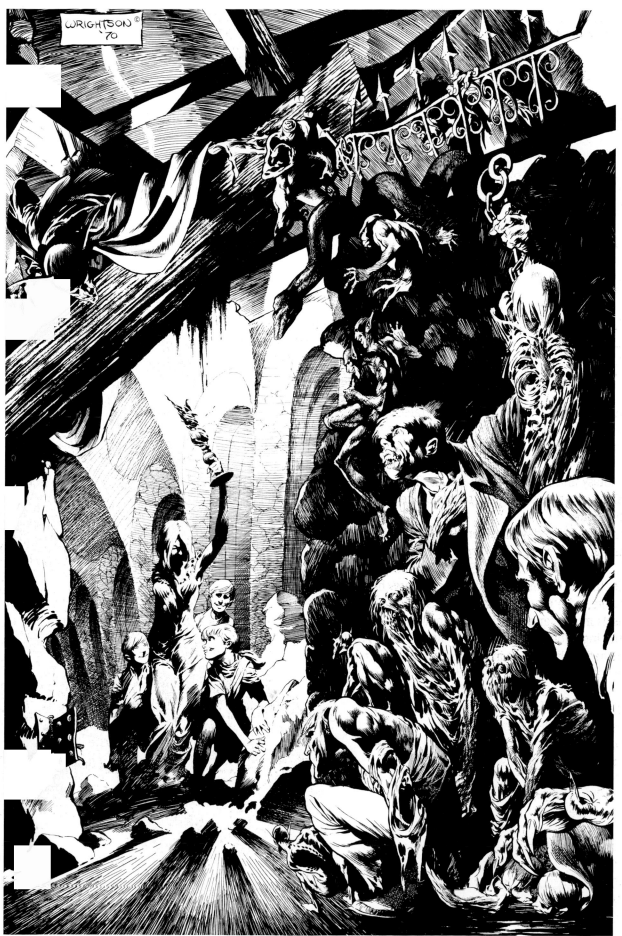

The Abyss.
Wall-to-wall horror by Bernie Wrightson.

©2004 Bernie Wrightson

The Pre-Code Era: E.C. Comics and Their Demented Cousins

If you don't know E.C. Comics, you don't know horror comics. It's as simple as that. In 1947, William M. Gaines inherited the floundering Educational Comics publishing company from his father, Max C. Gaines. In 1950, after failing to attract readers with romances and westerns, Gaines decided to take the types of stories being published in the pulp magazines—science fiction, fantasy, crime, and, most popular of all, horror—and do them as comics. He also renamed the company: "Educational" became "Entertaining."

At the time, most comics followed the same character, in a continuing story, issue after issue. Gaines decided to use instead a pulp magazine anthology format, with each issue containing five different short stories. The three horror titles birthed by Gaines for E.C. were *Tales from the Crypt, The Vault of Horror,* and *The Haunt of Fear.* To illustrate them, Gaines hired a roster of very talented, very different artists. He encouraged each of them to develop his own personal drawing style, rather than demanding that they all conform to a "house style" as most other comic publishers did. Gaines also made a point of playing to each artist's strengths, assigning stories to the artists whose styles fit best with the plot. Among E.C.'s stand-out artists were Al Feldstein (who also wrote for E.C.), George Evans, Jack Kamen, Johnny Craig, Reed Crandall, Bernie Krigstein, Wally Wood, Jack Davis, and "Ghastly" Graham Ingles. All were enormously talented, but the two whose work truly came to define both E.C. and the classic look of American horror comics were Davis and Ingles.

Jack Davis's fun, energetic, almost cartoony style played up the dark humor of E.C. Comics. This is not to suggest that Davis's art wasn't scary when it needed to be. His exaggerated style lent itself beautifully to slimy corpses, shadowy-faced killers, slavering werewolves, sexy vampire women, and dismembered bodies.

©2004 Vincent Locke

The Invisible Man

Vince Locke has used black and white to maximum advantage in evoking this famous character's murderous rage.

©2004 Bryan Baugh

Vampires in Love

Gives "eternally yours" a whole new meaning.

He's Going to Need a Bigger Snowball!

A night when the moon is full is no time to go goofing around in the woods.

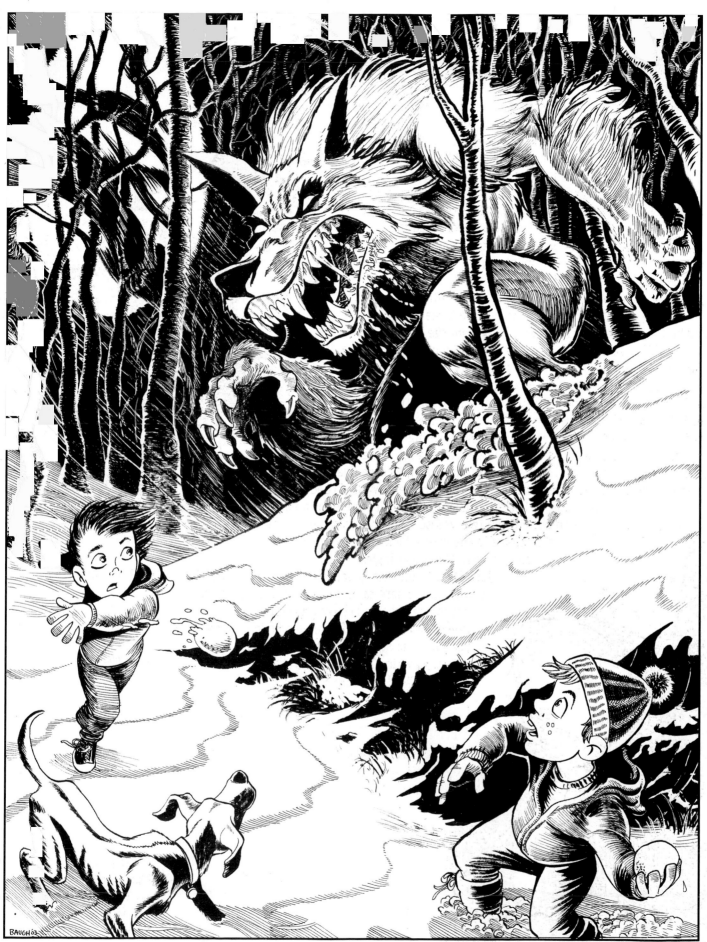

©2004 Bryan Baugh

BAUGH 03

Graham Ingles, who always just signed his name "Ghastly," was the more somber of the two. Ingles's signature blend of fine-line pen techniques with heavy brushwork gave his works a spidery, liquidy look. Everything in Ingles's world appears to be ancient, melting, and decaying. As you can imagine, this made Ingles a master at drawing E.C.'s trademark living corpses, not to mention evil old men, deformed mutants, rotting haunted houses, and fog-enshrouded graveyards.

What fired the imaginations of the E.C. writers and illustrators? In the United States, the popular craze for horror had reached a peak in in the 1930s and 1940s, when Universal Studios brought the classic characters and themes of 19th-century European horror literature to the screen, releasing, in rapid succession, *Dracula* and *Frankenstein* (1931), *The Mummy* (1932), *The Invisible Man* (1932), *The Bride of Frankenstein* (1935), and *The Wolf Man* (1940). These films were the runaway smash hits of their time, beloved by both children and adults, who formed lines around the block and

Date Stake

Part of your job as an artist is to choose scenes which—at a glance—convey to the viewer the overall idea of a particular narrative sequence. Here artist Mitch Byrd masterfully depicts the outcome of an encounter between a vampire and a would-be vampire slayer. All you need to know about their meeting is captured in this single panel.

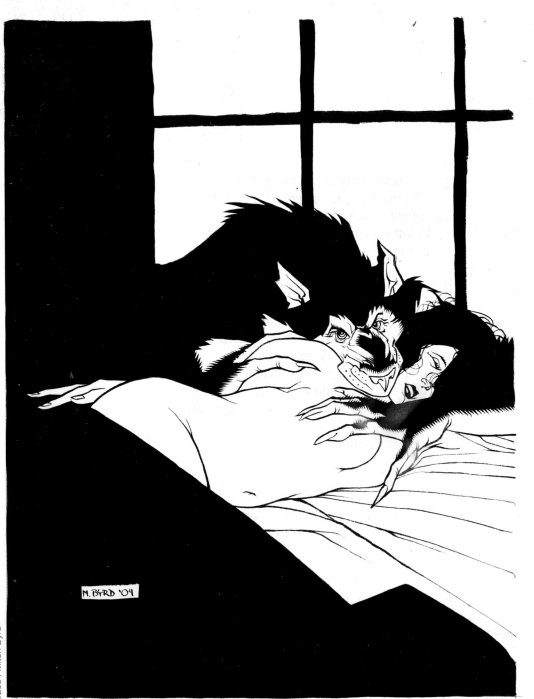

Midnight Wolf

Simple shapes and stark black on white brushwork make this Mitch Byrd piece really pop. Sometimes the simplest approach is also the most effective, especially in horror, where large areas of black provide ample space for several nightmares to remain half-hidden by the shadows.

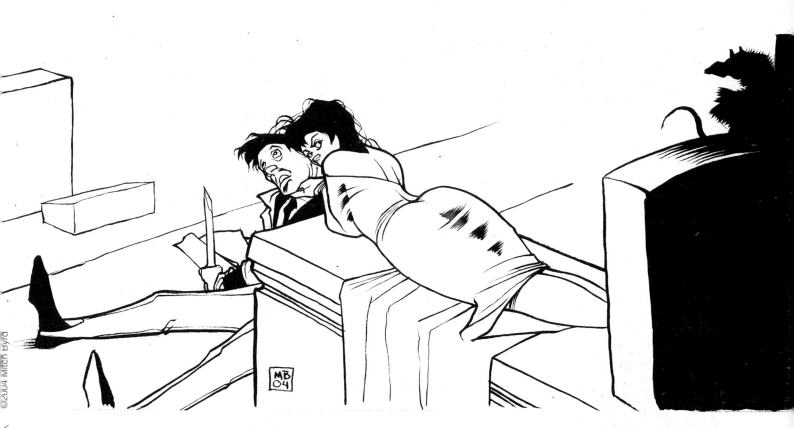

returned to the theater for multiple viewings. Two other early horror flicks, *Cat People* (1942) and *I Walked with a Zombie* (1943), both from RKO, are considered the first psychological horror thrillers. This trend began twenty some-odd years before the creation of E.C. Comics, when many of the E.C. writers and artists would have been children. So it makes some sense that there is a potent atmosphere of the old Universal monster movies in the E.C. books.

Although the bulk of the E.C. stories featured living corpses (always of the rotting, slime-dripping, skeletal variety) as their star monsters, tales about vampires and werewolves were also common, and every once in a while, there'd be a story with a mummy or a Frankenstein-style creature drawn to resemble the Universal versions. As in the Universal films, settings frequently included ancient houses, lonely graveyards, spooky forests, and murky swamps. Panels were often embellished with billowing fogbanks, thick drapes of cobweb, and a careful, artistic arrangement of shadows. There was always a rat scurrying somewhere, a spider dangling from a thread, or a flock of bats flapping past a full moon.

But E.C. did three major things that set their comics apart from anything that had gone before and gave them an entirely different feel. First, most of the stories were set in present-day America, rather than the exotic European locales in which so much earlier horror fiction had been set. During the 1950s writers such as Jack Finney (*Invasion of the Body Snatchers*), Ray Bradbury (*Something Wicked This Way Comes*), and Richard Matheson (*I Am Legend*) had begun writing successful horror stories that took place in familiar, modern towns much like yours and mine. It was an approach that brought traditional horror fantasies closer to home and, therefore, made them scarier.

Another major change was E.C.'s infamous inclusion of blood and gore. Cover illustrations regularly depicted scenes of graphic violence and death. Interior artwork went even further. Stories regularly ended with somebody getting killed in particularly imaginative and hideous ways. Characters were eaten alive by monsters, sliced and diced by machines, burned or buried alive, decapitated, dismembered, cooked, drowned—you name it. The last panel of those tales was usually a gruesomely detailed illustration of the victim's remains.

Finally, whereas most classic gothic/horror tales ended with the hero vanquishing the monster, in many E.C. stories, the "hero" would be murdered by the villain—always in some particularly horrific way—halfway through the story. The villain was never found out, arrested, or sent to jail for his crimes. But by the end of the story, the dead hero would rise from the grave as a living corpse, seeking its revenge. Once it caught up to the killer, the rotting undead thing would finish off the villain in an ironic manner that was reminiscent of—but even more gruesome than—how the hero was dispatched.

These wild, over-the-top stories were always done with a demented sense of humor. No rational person could read an E.C. story and take it seriously. But for kids of the 1950s, in an era when comic books were dominated by superheroes, cowboys, and funny animals, this was . . . something else.

The E.C. horror titles sold—and sold extremely well. They were also imitated by a flood of other publishers, who began putting out their own anthology horror comics, very obviously patterned after the formulas pioneered by William M. Gaines and his crew. There was Ace (*Web of Mystery*); ACG (*Skeleton Hand*); Ajax-Farrell (*Haunted Thrills*); Atlas (*Adventures into Terror*); Avon (*The Dead Who Walk*); Charlton (*The Thing!*); Comic Media (*Weird Terror*); Fawcett (*This Magazine Is Haunted!*), Fiction House (*Ghost Comics*); Gillmor (*Weird Mysteries*); and Standard (*Out of the Shadows, The Unseen*), among others. Their stories weren't as imaginative as those in the E.C. books, but some of these imitators managed to bring quality artists on board. Artists who were nearly up to the E.C. standard included Matt Baker, L. B. Cole, Matt Fox, Don Heck, A. C. Hollingsworth, and Rudy Palais. Then there was the wonderfully weird Basil Wolverton, who was good enough—and unique enough—that many fans (including this author) agree that he should have been part of the E.C. line-up from the beginning. For whatever reason, this fascinating artist never worked for them.

Between the three titles being published by E.C. and the avalanche of material being produced by their imitators, horror-themed comic books began to dominate the newsstands. Suddenly shambling things from beyond the grave were more popular than Superman.

In 1955 the axe came down.

A psychiatrist named Fredric Wertham, convinced that violent comic books were the cause of juvenile delinquency, went after William M. Gaines like Van Helsing going after Dracula. Wertham wrote a book on the subject called *The Seduction of the Innocent* and launched a political campaign designed to put E.C. and its imitators out of business forever.

Gaines testified before Senate hearings to defend his right to publish whatever subject matter he chose. He pointed out that children were far more competent, intelligent, and moral than Wertham's camp gave them credit for, and argued that juvenile delinquency was the result of bad parenting, not comic books. In the end it was the distributors who settled the issue by simply refusing to carry any more comic books that reeked of the grave. Once that happened, companies were forced to dump horror and start printing new subject matter or go out of business. Many of the imitative horror comics publishers quickly went under and were never heard from again.

Meanwhile, the major comic book companies, in what appeared to be a desperate attempt to get back on America's good side, created what they called the Comics Code Authority, a self-imposed censorship board designed to regulate what sort of content was and wasn't permissible in the pages of comic books. Out went blood, violence, and the living dead.

Ironically, E.C. Comics itself, the bull's-eye on Wertham's target, was one of the few companies that managed to survive this onslaught. They did so only by closing The Crypt, locking up The Vault, and ending The Haunt. Within the space of a few months, Gaines cancelled all of his classic horror titles and went on to publish *Mad* magazine, the famous humor periodical which survives to this day.

After the Code:
More Monsters, Less Blood

For the next decade, the Comics Code remained firmly in place. A nation of overprotective parents and politicians watched over the quivering remains of the comics industry like angry villagers watching over the burned-down wreckage of Castle Frankenstein, whispering in hushed tones about the awful thing that happened there once, swearing they would never allow it to happen again. And so, quite wisely, those comic book companies that survived Wertham's witch hunt took a break from horror for a few years.

By the mid-1960s, television had begun to air repeated showings of old black-and-white monster movies like *Dracula*, *Frankenstein*, and *The Wolf Man* on the small screen late at night, thus creating a whole new generation of monster fans. Around the same time, publisher Jim Warren took advantage of the new monster boom and simultaneously side-stepped the Comics Code problem altogether by printing magazines with titles like *Eerie* and *Creepy*, which featured horror comics stories, but in a much larger format. The Warren magazines, many of which had wonderful covers by legendary artist Frank Frazetta, were considered art magazines rather than standard comic books and were therefore not bound by the Code. But comic book publishers, who seemed to have had the horror beaten out of them by Fredric Wertham, spent most of the 1960s churning out light-hearted fare featuring—you guessed it—more superheroes.

But horror is a thing that never really dies, because after all, it was already dead to begin with. At the same time that comics were hewing to the Code, horror films began what was to be a major comeback. *Psycho* (1960) and *Rosemary's Baby* (1968) depended more on suspense and atmosphere than explicit on-screen violence to scare moviegoers, but *Night of the Living Dead* (1968), *The Exorcist* (1973), and *The Texas Chainsaw Massacre* (1974) ratcheted up the gore quotient. Horror was once again big business.

Gradually, comic book publishers began testing the market with new fright fare. The horror comics of the 1970s were plot-driven and heavily atmospheric. They had to be. Denied the free-wheeling blood and violence of the old E.C. days, publishers wisely shifted their focus to the monsters themselves. Marvel Comics, which had made a fortune with such titles as *Spider-Man*, *Fantastic Four*, and *X-Men*, started putting out books starring their versions of horror's most iconic monsters.

First there was *Tomb of Dracula*, moodily written by Marv Wolfman and masterfully illustrated by Gene Colan, a perfect creative team for this subject matter. Wolfman and Colan told their epic story over the course of a series that lasted for 70 issues. In this series, Dracula was hunted through modern times by Quincy Harker and Rachel Van Helsing, the descendants of his original arch enemies from the Bram Stoker novel.

Then there was *Werewolf by Night*, which took sort of an Incredible Hulk approach to the Werewolf legend, telling the story from the point of view of Jack Russell, a young man who was actually the werewolf in the title. Russell wandered from place to place, stumbling into various adventures in which his monstrous transformation was the only thing that saved him. Various writers and artists contributed to this series. Many were good, but without a doubt, the most memorable issues were those drawn by Mike Ploog.

Other Marvel monster titles of the seventies included *Ghost Rider*, *The Monster of Frankenstein*, *Tales of the Zombie*, *The Living Mummy*, *Morbius the Living Vampire*, *Devil Dinosaur*, *Man-Thing*, and many others.

Meanwhile, DC Comics, famous as the publishers of Superman and Batman, were putting out their own lineup of new horror titles: *The Demon*, *Unexpected*, *House of Mystery*, *House of Secrets*, *Weird War Tales*, and others.

Bernie Wrightson:
The Master of the Macabre

From the pages of *House of Mystery* and *House of Secrets* emerged an artist named Bernie Wrightson, who, over the course of the next two decades, would earn the title "The Master of the Macabre." His early cover illustrations for DC's new horror anthologies already revealed an amazing talent. With a style that was influenced by artists like Graham Ingles, Frank Frazetta, and Jack Davis, but at the same time was uniquely his own, Wrightson quickly became a favorite among readers. It wasn't long before DC teamed up Wrightson with writer Len Wein to create a series called *Swamp Thing*, inspired by a *House of Secrets* short story that Wein and Wrightson had collaborated on a year earlier. Pouring themselves into this new project, Wein and Wrightson created what is today considered a classic work in the genre of horror comics.

Swamp Thing tells the story of Dr. Alec Holland, who, with his wife Linda, set up a secret laboratory in the soggy, boggy Bayou Country, to work on an experimental biorestorative chemical designed to accelerate plant growth. One night, Dr. Holland's lab is invaded by criminals who want to steal his invention. A fight ensues and a fire starts, destroying the lab in an explosion. Linda is instantly killed. Dr. Holland is thrown into the swamp, where he sinks to the floor of a murky pond. Over time, the biorestorative agents burned into Dr. Holland's ruined body somehow mix with the primordial mud and vegetation of the swamp, transforming him into a half-man, half-plant monster called Swamp Thing. The bulky green Thing arose from the scummy water, its slimy, muscular body entangled with rootlike veins, its eyes burning bright red, its tortured mind bent on revenge.

Wein flooded the series with descriptions of Swamp Thing's overwhelming emotional turmoil. It was impossible not to pity the tortured creature, doomed to wander the earth and haunted by memories of its dead wife. Over the course of ten issues, Wein's clever scripts took "Swampy" on a long search for answers and into many strange adventures, battling mad scientists, werewolves, witches, the Patchwork Man, and a horde of others. But it was Wrightson's art that truly gave this series its heart and soul. With a combination of intricate, fine linework and large areas of drowning black shadows, Wrightson's extraordinary vision gave the Swamp Thing series the look of a 1930's Universal horror movie world populated by E.C. Comics monsters.

Wrightson later moved from DC to Warren Publishing, where his black-and-white work was reproduced the way it was intended to be, and on a larger format. He would go on to illustrate books for Stephen King, and would create a masterpiece of modern fantasy art with his Marvel Illustrated Edition of Mary Wollstonecraft Shelley's *Frankenstein*.

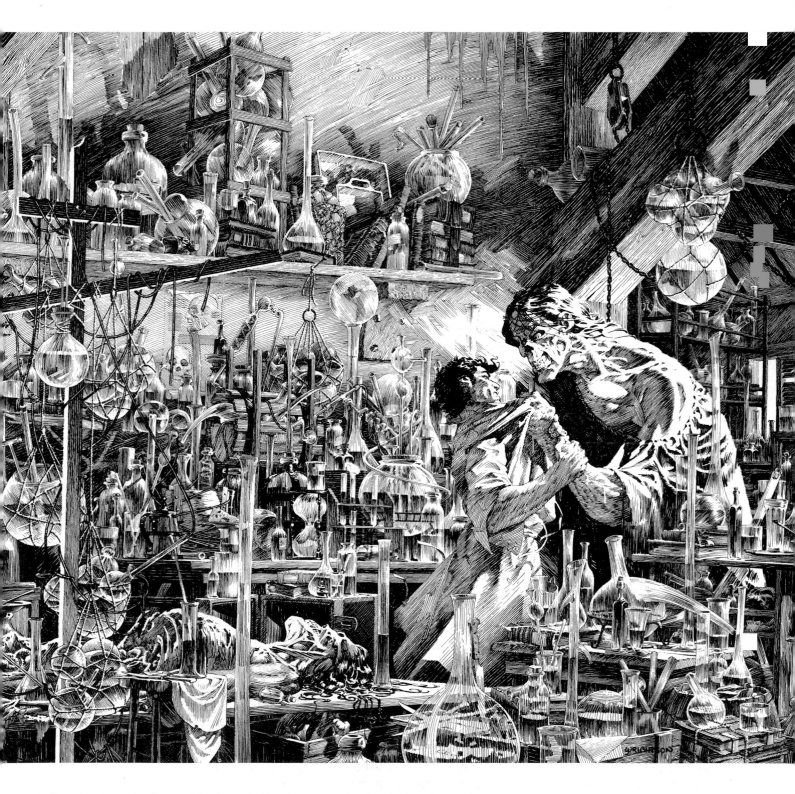

In his classic work, *Bernie Wrightson's Frankenstein: Or the Modern Prometheus*, Wrightson used pen and ink to recapture the look of woodcut or steel engraving, illustration techniques used in 1831, when the book was originally published. This glorious two-page spread demonstrates both Wrightson's unparalleled inking skills and ever-careful construction. Despite the incredible clutter of the room, and the fact that every object is drawn in flawless detail, the viewer's eye is drawn directly to the central image of the Monster throttling its creator.

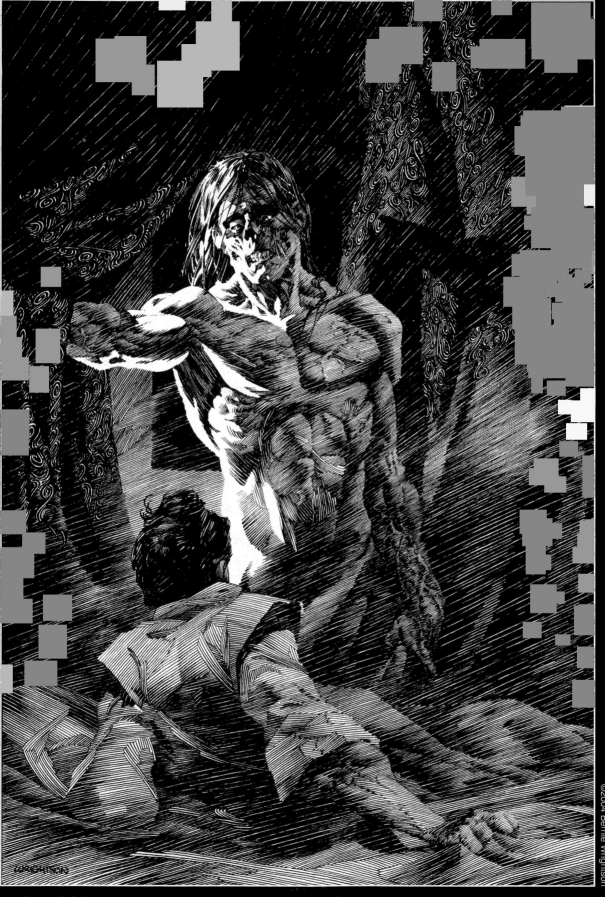

Frankenstein's Dream

"His eyes, if they can be called eyes, were fixed on me."

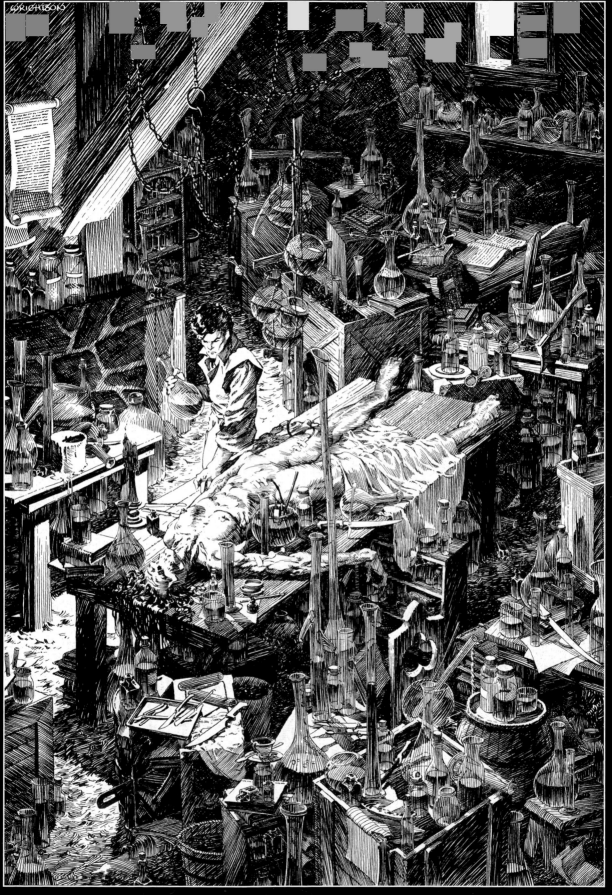

The Monster's Bride

"It was, indeed, a filthy process. . . . My heart often sickened at the work of my hands."

The Gory 80s

The 1980s was a landmark decade for horror.

Stephen King was clearly America's favorite novelist, turning out a constant stream of best-selling fiction including *Carrie, Salem's Lot, The Shining, The Stand, Night Shift, The Dead Zone, Cujo, Christine, Pet Sematary*, and *It*.

New horror films and sequels to extant horror films appeared at movie theaters almost every single week. These films became a playground for special effects and makeup artists looking for new ways to terrorize audiences. For brilliant young effects wizards like Tom Savini, Rick Baker, Rob Bottin, and others, this meant creating some of the most realistic monsters the movies had ever seen. It also meant creating some of the most realistic blood and gore the movies had ever seen. In fact, the more realistic they made it, the more the audiences wanted to see it. Rick Baker's work on an *An American Werewolf in London* (1981) prompted the creation of a new Academy Award, for special makeup effects.

Fangoria magazine, dedicated to coverage of horror entertainment, began appearing on the newsstands. "Fango," as its readership affectionately called it, was filled, cover-to-cover, with fascinating behind-the-scenes articles, interviews with horror film directors, and of course, shocking, gory photos of modern horror film special effects on almost every page. In the 1980s the only thing more exciting than seeing the latest blood-drenched horror flick was learning about the next one coming out.

It took a while for the comic books to catch up to filmdom's accelerating levels of visual terror. In the early eighties, a company called Pacific Comics began putting out a series called *Twisted Tales*. Deliberately patterned after the E.C. comics of the 1950s, *Twisted Tales* was an enthusiastic attempt to revitalize old-fashioned anthology-style horror comics and simultaneously pay homage to E.C. itself. The writers and artists behind the series were all top-notch comics illustrators looking for a place to do harder, scarier material than the major companies would permit. Bernie Wrightson, Bruce Jones, John Bolton, William Stout, Richard Corben, Mike Ploog, Alfredo Alcala, Brett Blevins, John Totelbein, Joe Chiodo, Dennis Etchison, Thom Enriquez, and Mike Hoffman all contributed to this memorable series.

In the mid-80s, a number of other small-press publishers decided that there was good money to be made by exploring darker, edgier material in comic books. Most of them were humble operations, with just enough money to print color covers and black-and-white interior art. At the same time, they had the freedom to print anything they wanted. Needless to say, there were many who abused this freedom, but others did artful things with it. Gradually, a new breed of horror comics emerged.

One of the best independent horror comics of the eighties—and definitely the one with the greatest title of all time—was Fantaco's anthology-format *Gore Shriek*. The early issues of *Gore Shriek* were mad experiments in artistic lunacy. Stories ranged from hilarious works of satire to bizarre, almost abstract, mood pieces to truly creepy flesh crawlers. Although there were contributions by such artists as Steve Bissette, Chas Balun, and Greg Capullo, *Gore Shriek*'s main attraction was the artwork of Bruce Spaulding Fuller. Loaded with detail, Fuller's explosive artwork resembled the hallucinations of a demon-possessed homicidal maniac set to paper. Fuller's illustration for the cover of *Gore Shriek*'s first issue was a perfect introduction to the series: a zombie, its eyeballs bulging and its jaw dropped in a scream appears to be ripping off the flesh and muscle tissues of its own face. In the lower right-hand corner was the tagline: "Warning: Contains disturbing material and is not intended for children!" This was not false advertising. The stories within delivered exactly the sort of horror promised on the cover. It is unfortunate that the greatness of *Gore Shriek* really only endured for the

Teenage Werewolf

The high school gymnasium is a bad place to hang around when there's a teenage werewolf on the prowl.

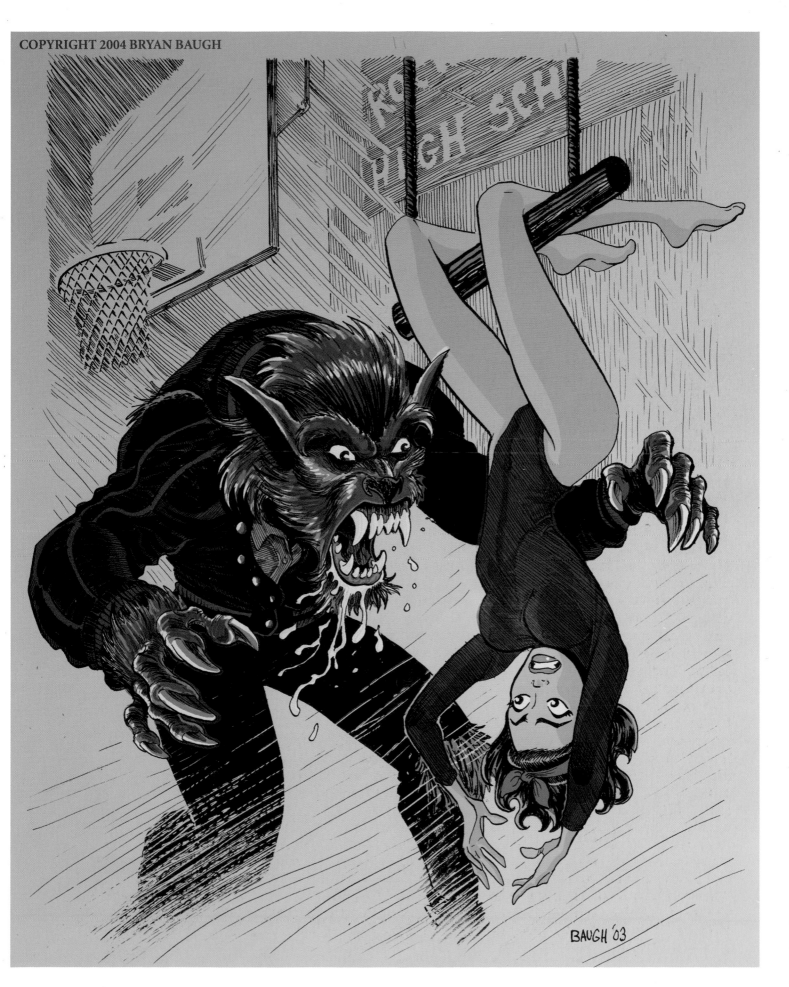

book's first five issues. After that, Fuller moved on, and the series slowly dwindled into obscurity. But it was one beautiful nightmare while it lasted.

Around the same time, Caliber Press began publishing two great horror/action titles. First there was *Deadworld*, a series with a long-running storyline that continued from issue to issue like some epic comic book version of *Night of the Living Dead. Deadworld* was brought to life by the wonderfully loose and energetic art of Vincent Locke. Drawing almost entirely with scratchy lines, scribbling, and cross-hatching, Locke gave this series an atmosphere that buzzed and bristled with the threat of violence. Locke's human characters were bleak, wasted beings, and his zombies were messy, maggot-infested figures of chaos and evil.

Then there was *The Crow*, written and illustrated by Jim O'Barr. This ultra-violent tragic poem of a comic book told the story of Eric, a young man returned from the dead to take revenge on the gang of street criminals who murdered him and his beautiful fiancée. As the Crow, the wraithlike, undead Eric uses black greasepaint to turn his face into an ironic smile. Each time he guns down a victim, he ties the spent shell casing to a lock of his spiky black hair. The resulting image is that of a goth rock angel of death. O'Barr's writing was dreamy and lyrical, at points diving to tear-jerking depths of pain and regret. His artwork was angry, dark, and fevered, employing heavy brushstrokes and large areas of black to describe the ugly world of crime-ridden ghettos the Crow haunted in the middle of the night. During the course of its original five-issue run, *The Crow* was relatively unknown except to its small cult audience. But a work like this could not remain small for long. Almost immediately after the publication of the fifth and final issue, O'Barr struck a deal for a film adaptation. The rest, as they say, is history, and by the mid-1990s *The Crow* had become a major franchise, spawning sequel films and more comic books.

The return of E.C. horror comics started with Stephen King. King, a faithful reader of E.C. Comics when he was a child, often reminisced about them in his writing. In his short story collection *Night Shift* and his nonfiction book *Danse Macabre*, King described for a new generation his memories of *Tales from the Crypt*, *The Vault of Horror*, and *The Haunt of Fear*. In magazine interviews he explained that the E.C. storytelling style inspired many of the scariest scenes in his classic vampire novel, *Salem's Lot*. In 1982, King collaborated with George Romero to create the movie *Creepshow*. Written by King and directed by Romero, with special effects by Tom Savini, *Creepshow* was intended to be an issue of *Tales from the Crypt* come to life. King also wrote a comic book adaptation of the film, beautifully illustrated by Bernie Wrightson, a natural choice. The result was a fresh demand for E.C.'s fifties classics, and before the end of the decade, publisher Russ Cochran reprinted all the E.C. titles in both standard comic book format and in lavish boxed sets of hardcover editions. The pages of the hardcovers were reproduced at their original size and without color, thus offering the best look ever at the fine work of the E.C. artists.

AN INTERVIEW WITH VINCENT LOCKE

Besides inking *Deadworld*, Vincent Locke has done some frightful work for DC Comic's Vertigo imprint, *Moonstone, White Wolf,* and various role-playing games (RPGs) and album covers. The following interview with Locke was conducted by Steve Miller.

SM: Did you have any formal artistic training?

VL: Two years of graphic design in college and several years of private instruction.

SM: When you broke into comics at the tail end of the independent black-and-white explosion of the late eighties, you worked with two small independent publishers, Arrow and Caliber. What was that like?

VL: It was very important for my development. I learned a lot about art and storytelling doing ten issues of an independent comic. It's rare for artists to get that kind of

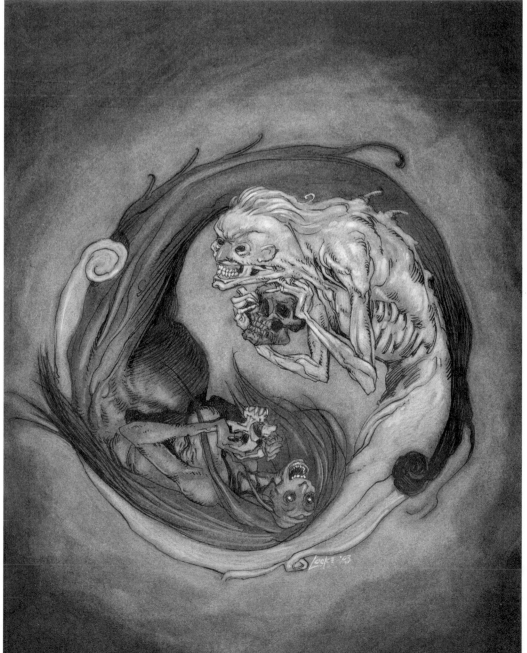

Grinders

Here Vince Locke has illustrated a spooky variation of the classic "yin-yang" symbol using a combination of inks, various pencil leads, and paint.

Maggot Eyes

By zooming in on King Zombie's decomposing countenance, Vince Locke is able to draw out a short verbal exchange for horrific effect.

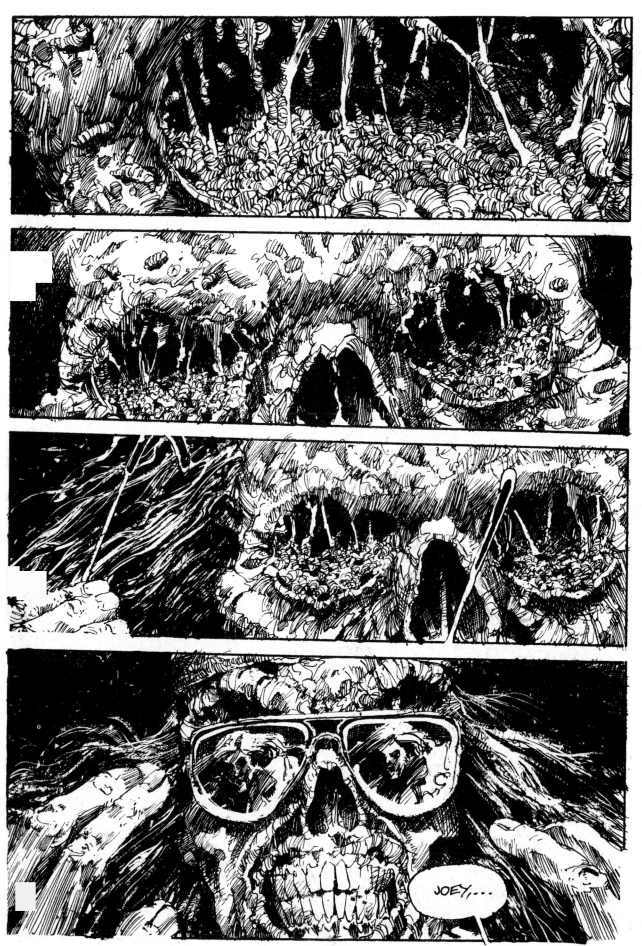

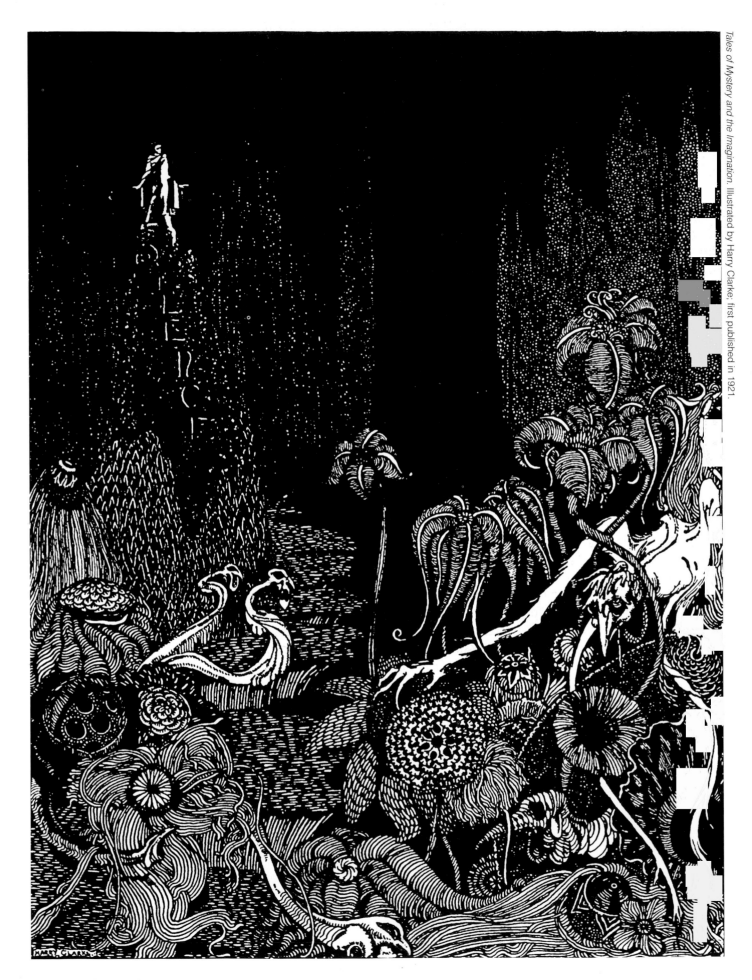

Tales of Mystery and the Imagination. Illustrated by Harry Clarke; first published in 1921.

opportunity today, but artists starting out should at least try to do stories of 6 or 8 pages. Anything less than that and you miss out on learning the art of telling stories.

SM: How did you break into the big leagues at DC Comics and land some prime assignments like *Sandman* and *A History of Violence*?

VL: A friend started working for Vertigo comics and he passed along my name to his editor.

SM: How is the atmosphere different at the big publishing house?

VL: The big difference is the deadlines. You have to meet your deadlines or they bring in someone else to do the work. They own the characters so they don't really need you. There are dozens of artists waiting to get the chance to do what you are doing.

SM: If you could jump in a time machine and talk to your "preprofessional" self, what advice would you give to your younger self?

VL: First, save your money. Being a freelance artist, you don't get a steady paycheck. Your busy times need to pay for your slow times.

And if you have your own ideas, work on those. It's much more enjoyable. Don't be afraid of rejection. Send your art to everyone. If you get a rejection letter, send new samples a couple of months later.

SM: Who were some of your major artistic influences?

VL: Book and magazine illustrators from the late 1800s and early 1900s. In particular, Joseph Clement Coll and Harry Clarke.

SM: What about their work appealed to you?

VL: They had very different styles, but they were both masters with pen and ink. Joseph Clement Coll was great at creating shadowy, moody drawings. Harry Clarke created wonderfully bizarre creatures.

[Editor's Note: Harry Clarke (1889–1931), stained glass artisan and illustrator, drew dark, disturbing illustrations for numerous books, including Poe's *Tales of Mystery and Imagination* (1919) and *Faust*. Clark's biographer Nicola Gordon Bowe says of his work for *Faust* that it anticipated the "psychedelic, drug-induced fantasies of the 1960s." Joseph Clement Coll (1881–1921), a pioneer in the art of drawing with brush and pen and ink, illustrated numerous pulp serial classics by popular authors, including Arthur Conan Doyle (*The Lost World*) and Sax Rohmer (*Fu Manchu*).]

SM: How important is doing supplemental freelance illustration like RPG's and the Cannibal Corpse album covers?

VL: It's important financially and creatively. It's important to try different things to grow as an artist.

SM: What scares you?

VL: The dark.

But There Was No Voice Throughout the Vast, Illimitable Desert
This beautiful, disturbing drawing by Harry Clarke for Edgar Allan Poe's "Silence: A Fable" illustrates a landscape described in the story as a "horrible, lofty forest," where at the roots of trees "strange poisonous flowers lie writhing in perturbed slumber."

Till the Next Full Moon: The Turn of the 21st Century

Unfortunately, the horror boom of the 1980s couldn't last forever. With a few exceptions (e.g., *Hellraiser* and *The Re-Animator*) the majority of films being released toward the end of the decade were sequels to the quality horror films produced during the early and mid-80s. By 1989, for the first time in almost twenty years, the public was tired of horror, and looking for something new.

In the comic book world, superheroes came back in a big way. Sales of horror titles dwindled, and many publishers just stopped putting them out. In the early 1990s, the closest thing to horror was Todd McFarlane's *Spawn*, which, when you looked past the surface, was really just another superhero comic disguised as horror. Neil Gaiman's *Sandman* series and various comic adaptations of Anne Rice vampire novels were, technically, part of the horror genre, but they felt more like throwbacks to 19th-century Gothic romances than modern horror. A rather daring company called Chaos Comics emereged, producing titles like *Evil Ernie* and *Lady Death*. Although horror in these books tended to take third place behind humor and eroticism, Chaos is noteworthy, if only because they persisted in cranking out gory comics at a time when this was the least popular thing to do.

It wasn't until the mid-90s that a true horror title finally appeared, like one good, hard rain in a desert: a miniseries by writer/artist Mike Mignola, called *Hellboy: Seed of Destruction*. Harkening back to a pulpy, 1930s style of horror and adventure fiction, Hellboy told the story of a black magic ceremony performed by a team of Nazis during World War II. Led by the evil sorcerer Rasputin, the Nazis managed to successfully summon a baby demon to Earth, believing they could use it to conquer the world. However, the demonic infant was captured by American soldiers, who took it home and raised it to adulthood in a secret Army base. "Hellboy," as the soldiers called him, grew up to be a good-natured, well-meaning American citizen. He became a paranormal investigator, working for the Bureau of Paranormal Research and Defense. Hellboy enjoyed the work—his assignments took him all over the world. But of course, it wasn't long before Rasputin returned and attempted to recapture and enslave the adult Hellboy for his own purposes. The sorcerer also summoned an ancient, H. P. Lovecraft-style Cthuhlu-creature, and the ending was a rough-and-tumble fight to the death between Hellboy and the forces of evil.

Seed of Destruction was only the first book in the series, and Mignola quickly followed it with more comics, chronicling Hellboy's adventures with the B.P.R.D. and his continuing struggle to figure out just what his existence on this earth means.

Even more effective than the giant monster fights or the pathos of its main character are the quieter moments in the series. Despite all of Hellboy's intentionally goofy humor, Mignola knows how to create a potent atmosphere of age and death. Hellboy regularly finds himself in lonely, shadowy corners of the world where ancient, blasphemous statues still stand, full of forbidden knowledge. Broken skeletons that have been lying in the dust for a few hundred years may suddenly breathe out words, warning our hero to Beware. Cavernous mountain ranges are often revealed as hiding places for large, hideous machines, apparently built by some long-dead villain for some evil, forgotten purpose. In such scenes, Mignola's blocky, high-contrast artwork is suitably grim. Simple shapes emerge from large areas of solid black to convey a feeling of impenetrable darkness closing in over everything. Overall, its combination of genuine spookiness and larger-than-life comic book action sequences have made Hellboy a favorite series of both longtime horror and superhero fans alike.

Which brings us to Richard Sala, the creator of the ongoing comic book series *Evil*

Eye, graphic novels such as *The Chuckling Whatsit*, and, perhaps his most enjoyable work, *Peculia*. Sala is interesting in the context of a history of horror comics because, to illustrate his various weird comics at the turn of this century, he has—whether intentionally or unintentionally—developed an art style reminiscent of that which appeared in the penny dreadfuls and pulp magazines at the turn of the last century. The figures, poses, and scenery which appear in Sala's simplified black-and-white world closely resemble those in the illustrations of late-nineteenth and early-twentieth century illustrators like Mary Byfield and Lee Brown Coye. The settings of Sala's spooky stories are always timeless villages with quaint architecture, crooked roads, and scary trees. The streets are crowded with hook-nosed old women who look like witches, snarling men who look like criminals, and other shady, suspicious types. When night falls, evil characters in long black coats lurk about, and in certain dark alleys there may or may not occur a random act of murder. In other words, stylistically speaking, Sala's work brings us full circle.

As the first decade of the new century rolls along, a new generation of monster-oriented comics has begun to appear. Comic books such as *30 Days of Night* by Steve Niles, *Scary Godmother* by Jill Thompson, *The Goon* by Eric Powell, *Lenore* by Roman Dirge, *Rite* by David Hartman, and illustrated magazines with titles like *Carnopolis* and *1313*, not to mention the growth of companies like Slave Labor Graphics, Boneyard Press, Chanting Monks Studios, and Top Cow, all suggest that horror may once again be stirring in its grave and anxious to return to the surface of popular culture.

But one thing is certain. That which is already dead cannot die. Horror may sleep for a while, but sooner or later, the old rotted thing will come back. It always does.

Ghost Candles
Sometimes you will want to experiment with forms drawn white on black, rather than black on white. Artist Mitch Byrd drew the ghost's spirit forms using white opaque paint directly over the black background as the final step in this illustration.

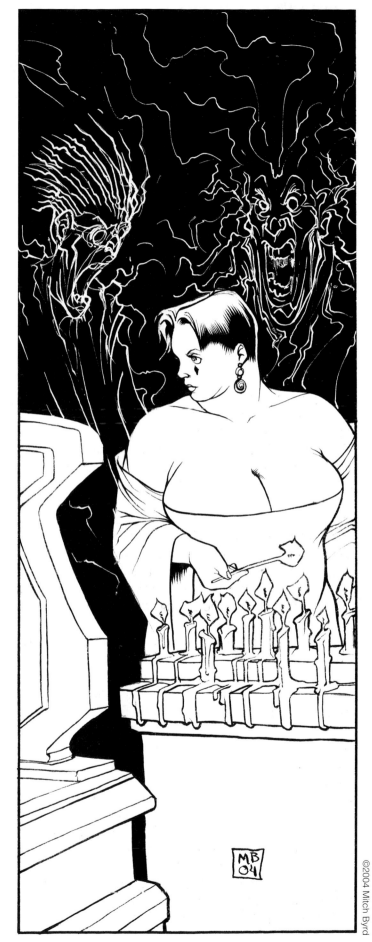

AN INTERVIEW WITH TOP COW COMICS

No discussion of contemporary horror comics is complete without mentioning Top Cow Comics. Top Cow's *Witchblade* is described by Scott Tucker, an associate editor at Top Cow, as a "realistic/superhero/suspense" type comic, but *Darkness*, a series featuring Jackie Estacado, a mafia hit man cursed with the power of "The Darkness" that gave him control over a demonic hoard that obeyed his commands, was as much horror as hero. When the series began, the "darklings" were like evil gremlins who would sometimes banter back and forth with Jackie, but as the series progressed, *Darkness* became much grimmer, with the demons dealing out death, destruction, and mayhem on behalf of Jackie.

In the following interview conducted with Scott Tucker, Associate Editor, and Phil Smith, Submissions Editor, at Top Cow, Steve Miller asked Tucker and Smith to talk about the horror genre.

SM: Top Cow started out publishing in the superhero genre, but gradually made a move to more supernatural-based subject matter. What spurred the metamorphosis?

ST: There is no one thing that brought on the change. And in fact we are now publishing some more classic-style superhero types of books again. What we try and do is publish books that we find interesting, and hopefully different from what other companies do. In the core of things there will always be folks that enjoy scary moves and books, so I think there will always be audiences for comics with a horror feel to them.

PS: Top Cow definitely has a stake in the macabre and occult niche: titles like *Witchblade*, *Darkness*, and *The Magdalena*, although they have superheroic leads, have a strong lean into mysticism and the occult, and feature stories that involve gruesome, unsolvable crime (which is why you'd need a superhero in the first place).

SM: What makes for a good horror book?

ST: Suspenseful writing, and creepy art. After enjoying a good horror book readers should be worried about having nightmares while they sleep.

PS: Fear. Being able to inspire the emotion of fear in someone through the medium of art and text. "Horror" doesn't need to be graphic (thank you, Mr. Alfred Hitchcock). Fear is in the mind. I can look at a body that has been ripped to shreds by a wild animal and never blink, but seeing the look in an animal's eye knowing that it wants to eat me is scary.

SM: What do you think of the current state of horror-based comics?

PS: The most popular horror-based comics on the market have gone back to ancient symbols, archetypes, and icons of the horror genre, namely zombies and vampires. Steve Niles's *30 Days of Night* and Robert Kirkman's *The Walking Dead* are two mainstream examples that spring to mind.

Kirkman's work is an editorial favorite here at Top Cow for his gallows humor and his believable and sympathetic characterizations. Tony Moore's art on the book is emotionally expressive but stays true to classic horror themes by giving us a good dose of rotting flesh and gore. [Editor's note: Moore illustrated the first six issues of *The Walking Dead*; then illustrator Charlie Adlard took over.]

Heads of Darkness

Jackie Estacado, wrenched back from the depths of hell, as depicted by Dale Keown.

Flying Demons

Dale Keown, fan favorite artist of the incredible Hulk, shows he can draw horror with the same flair he brings to drawing mammoth muscled men.

Wall of Demons

The very face of fear.

SM: What do you look for in an artist?

ST: Quality, of course, but also the ability to work fast. It doesn't matter how great the art looks; if the artist can't work within the schedule of a monthly comic then the art really isn't much use to me.

PS: All-around ability. Often times we will receive a submission with very stylized figures but with a lame background (two lines that are supposed to be a tower). Personally I also look for a fine arts background; that way you know the artist has had some type of formal training and has been exposed to more than just comic books.

SM: What are some of the common weaknesses you see in portfolios?

PS: A lack of "gesture" [the sense of movement and action conveyed by a sketch done with rapid, sure strokes], poor rendering, and most important, poor proportioning. New artists often struggle with getting the human body to look right because a lot of them start by copying someone else. We will often get bad representations of other established artists' work. It's understandable. You like someone and you want to be like them. The problem is without any formal training these artists take longer to figure out how to express themselves through their art. It's like they want to "channel" their heroes but

what they end up with is a bad artistic echo. That's why a background in classical art can be beneficial; it allows the artists to try new things but with a good foundation. Top Cow has a penciling internship program where new artists are mentored by other in-house artists, including Marc Silvestri.

SM: What advice would you give to a young artist just starting out?

ST: If you think you will regret more giving up then you will trying and getting rejected sometimes, then keep it up. You may succeed, and even if you don't at least you will know you tried, and you won't have to live with that "What if...?" feeling for the rest of your life.

PS: LISTEN to advice! Not all editors have a formal training in art, but they do have an eye. It's not the editor's intention to walk all over the artist's work (despite how criticism may make the artist feel), but to put together the best book possible.

SM: What scares you?

ST: Artists who are slow.

PS: Giger's Alien eating my parents.

Darkness #1, page 22

Working from a script by Garth Ennis, penciler Marc Silvestri and inker Batt brought a raw energy to the pages of Top Cow's *Darkness #1*.

EXAGGERATIUN

This section of the book is not meant to teach you the basics of effective illustration: figure drawing, perspective, composition, and linework. What you'll find here are a few pointers on how to warp your technique in order to achieve the right visual style for a horror comic.

Creepy Atmosphere

Okay, we're in the world of horror now, so think graveyards, old houses, castles, forests, and swamps. But there's a way to draw these things, and then there's a way to draw them scary. As any art teacher will tell you, you first have to learn to draw these things in a realistic manner. Artists hate hearing this, but the fact is, you can't draw the cool, fantastic stuff until you've put in some time studying the normal, everyday stuff. You've got to do some research. You want to draw a scary, haunted graveyard? Start by going out and looking at a real graveyard. Yes, some people will think you are morbid. Whatever. Ignore them, you've got a job to do. Take a camera with you. Get some good photo references to give you ideas later.

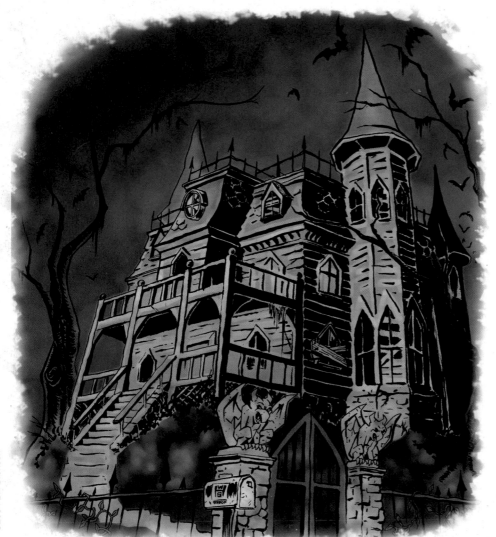

Bill Bronson's Haunted House

Real estate is easily handled by the undead. They don't bother with agents or movers— they just pick a spot, die there, and stick around for a few hundred years.

Monster Keeper

We don't know how she captured this particular monster (maybe he was left on her doorstep as a mere creatureling), or what she plans to do with him, but Art Adams is a master at getting us to ponder the gruesome possibilities.

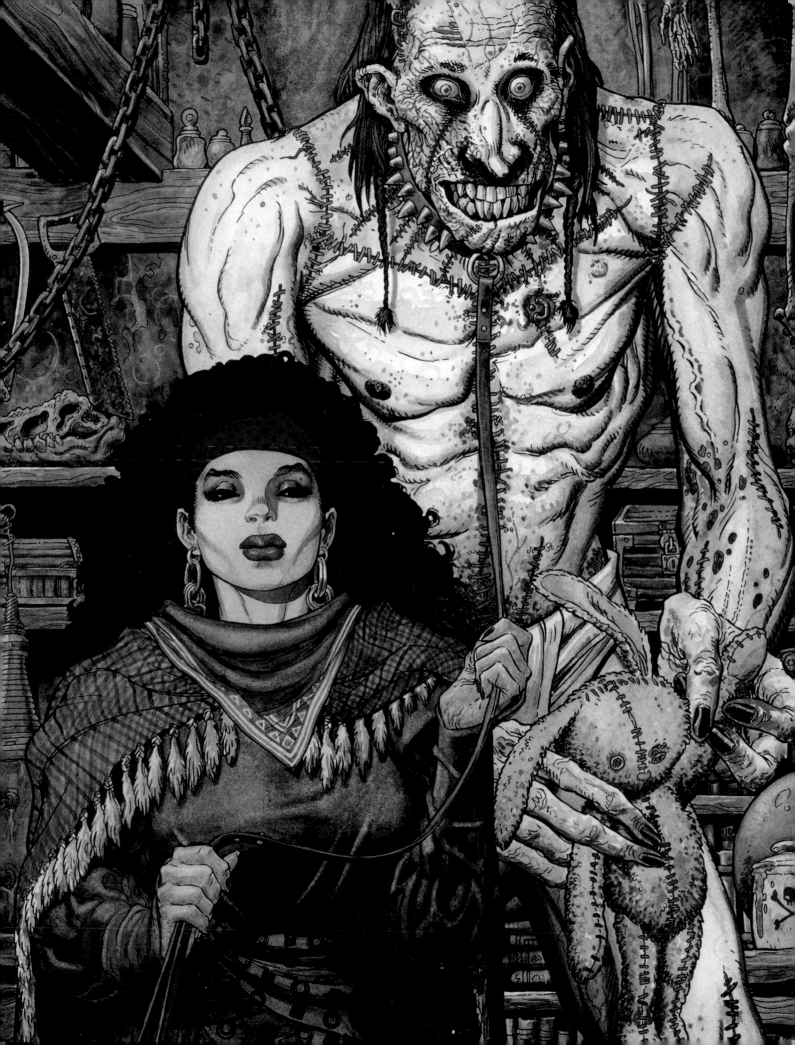

The same approach applies to drawing old houses, spooky forests, and all the rest. Try this and you will find that "realistic" does not have to mean "boring" or "mundane." The real world is full of strange surprises and unpredictable details. I don't care how imaginative you think you are. There are weirder-looking tombstones, trees, and structures out there in the real world than you could ever dream up sitting at home in your art studio.

Once you are able to draw these things realistically, then you can start putting that demented slant of horror on them. Exaggerate shadows into terrifying shapes. Make those tombstones look a thousand years old. Make your tree branches claw into the sky like twisted monsters.

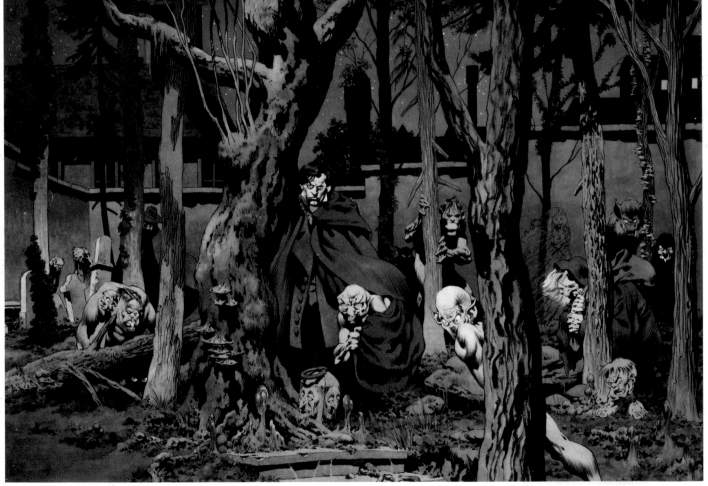

From ghoulies and ghosties, long~leggedy beasties, and things that go bump in the night, may the Good Lord deliver us.

Ode to a Scottish Prayer
Bernie Wrightson's fine visual ode to "Scottish Prayer" says it all.

©2004 Mitch Byrd

Haunted Woods

Another nightmare in black and
white by Mitch Byrd.

Sarisel

A wonderfully creepy demon tree
by Vince Locke.

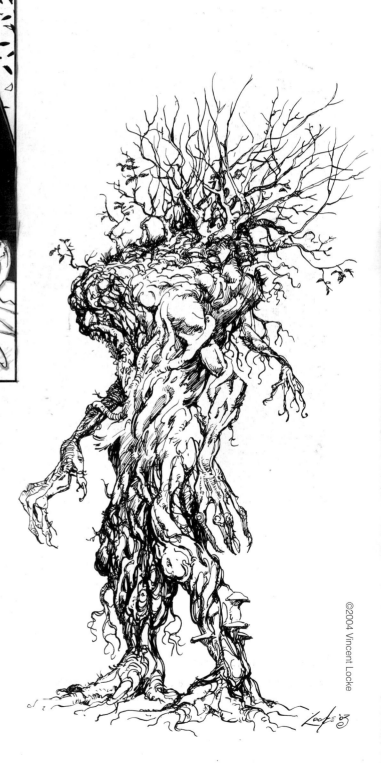
©2004 Vincent Locke

Creepy Characters

We're almost ready to call forth the horrific denizens dwelling in the cauldron of your imagination. First, let's take a moment to look over some basic principles of anatomy. Before you can break the rules, you need to know them. If you don't already have one, go out and buy a decent anatomy book and keep it close to your drawing desk. You can check it whenever you need to reference what muscles go where and which bones support which parts of the body. (You should feel lucky to have such a wealth of anatomical information so readily available. Renaissance artists like Leonardo da Vinci had to bribe undertakers to provide them with fresh cadavers to learn how the body was put together.) Once you understand the laws of human anatomy you can push them to their limits and even a few steps beyond.

Bodies

Books on drawing superheroes often encourage you to exaggerate the bulk and musculature of your star characters to make them more heroic or powerful-looking. That is sometimes—but not always—the best idea for characters in a horror comic. There can be something very unsettling about doing just the opposite: making your characters look terribly, painfully skinny, exaggerating their creepy scrawniness to the same degree that you would exaggerate a superhero's massive muscles. Go ahead and make your twisted horror characters look downright emaciated. Give them sunken eye sockets, hollow cheeks, extra-long arms and legs, and bony, spidery fingers. Show their cheekbones, shoulder blades, hipbones, and ribs pushing through their skin. Give them knobby elbows and knees.

The standard rule for drawing dynamic comic book characters is to make them proud and tall, with their heads held high, their backs slightly arched, and their chest thrust out. Well, that's a great look for Captain America or Superman. But a zombie needs to slouch. A werewolf should lunge forward. An old hag should look like she's in serious need of visiting a chiropractor. Frankenstein's monster was stitched together from a bunch of dead body parts, so he should look like he might just fall apart at any second. Horror characters are tortured beings, and their poses should be twisted and tortured as well. Their body language should make readers feel their pain.

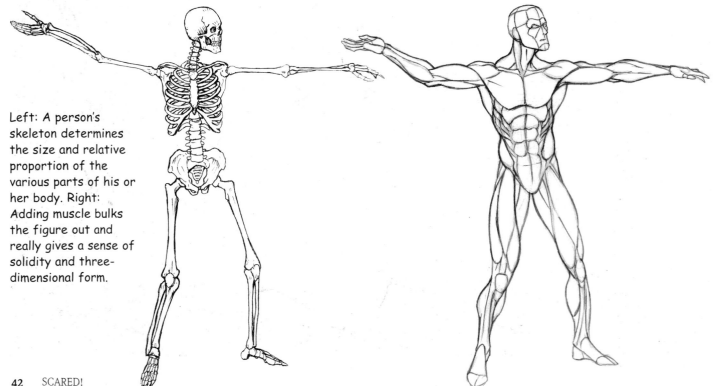

Left: A person's skeleton determines the size and relative proportion of the various parts of his or her body. Right: Adding muscle bulks the figure out and really gives a sense of solidity and three-dimensional form.

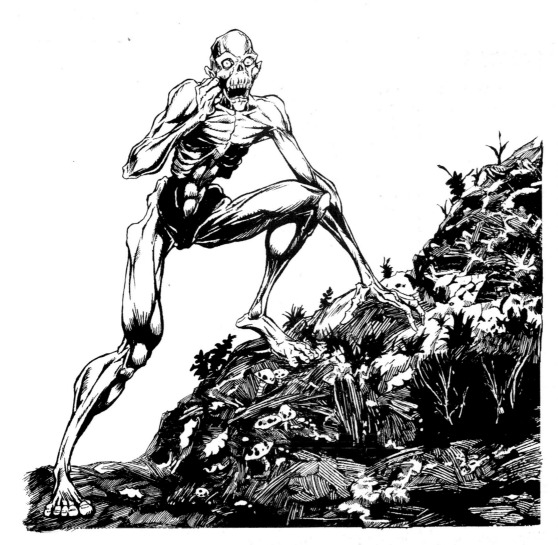

Skin and Bones

In this ghoulishly gaunt reanimated corpse the skeletal frame and the musculature are both based on a solid knowledge of anatomy.

All Bulked Up

The musculature of Big Blue here has been bulked up past the bounds of what is humanly possible.

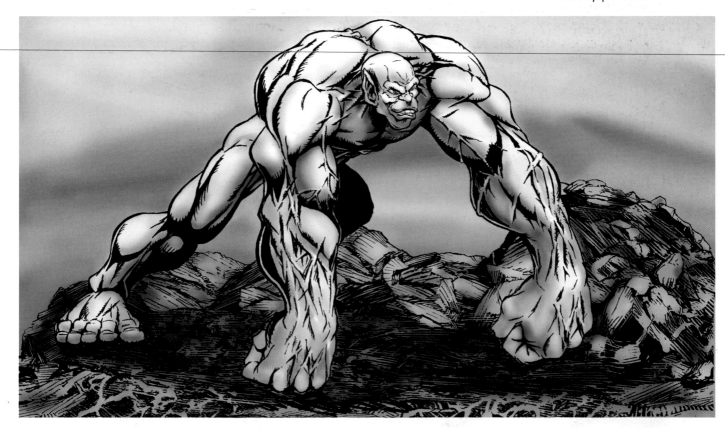

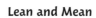

Lean and Mean

This Frankenstein's monster is impossibly elongated and lanky. Notice a few other scary details: how low his head is; his clenching, clawing hands; his inward-turning knees.

©2004 Steve Miller

Heads

Just as you need to be able to draw the human body realistically before you can create horrifically exaggerated yet believable monster bodies, you need to know how to draw "normal" heads before you can create monstrous variations.

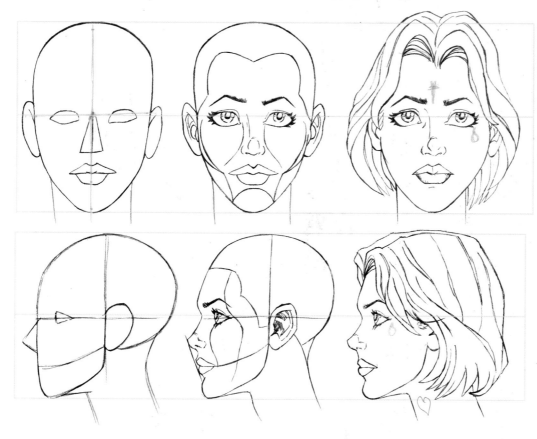

There are subtle differences between the male and female head, but a few general guidelines will help you in laying out either. The main forms to concentrate on are the sphere of the skull and the jawbone. Everything else is built off of those simple forms. It is a good idea to lightly draw a line that divides the head vertically in half: the two halves should be symmetrical. Place the eyes at about the midpoint between the top of the forehead and the base of the chin. If you divide the bottom half again you will know where to place the ears and nose in the upper half. The mouth falls roughly one-third of the way down from the nose to the chin.

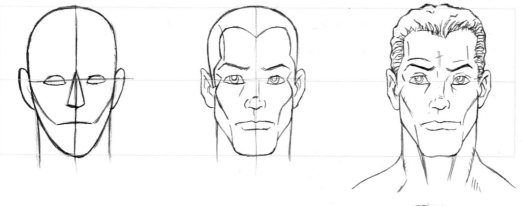

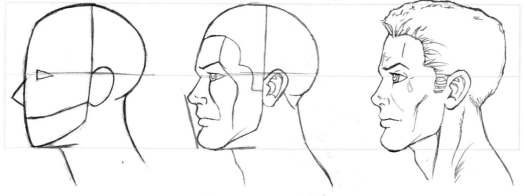

Take a look at the heads of horror in the accompanying illustrations. The degree of exaggeration varies, but in all of them, the basic underlying forms are there.

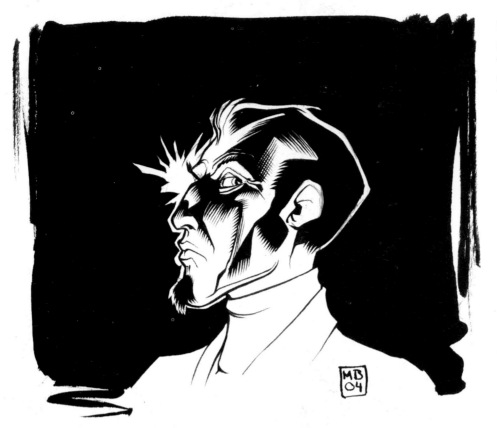

Lighting for Effect
Sometimes the easiest way to bump up the scare factor of an illustration is to light the character from below.

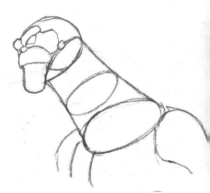

Al Rio's Monstrous Heads

Note how the artist has exaggerated a *different* part of each of these heads. Also notice that the heads, necks, and shoulders were built from basic geometric shapes: cylinders and circles.

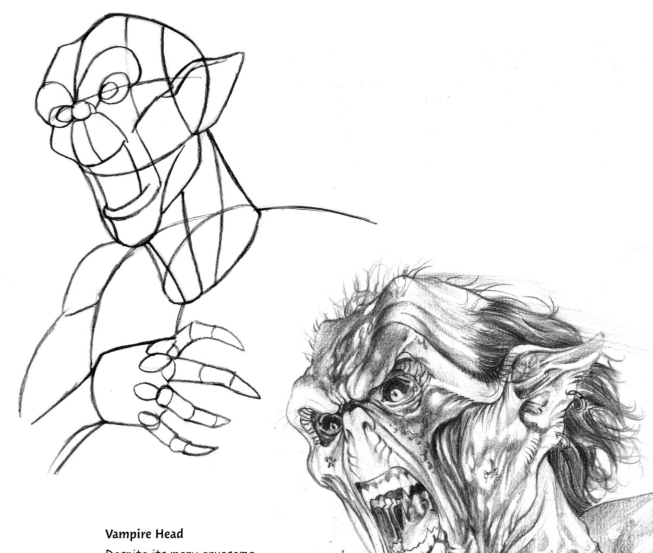

Vampire Head

Despite its many gruesome
details, Al Rio's vampire head
is built from basic shapes.

Clothes

Don't be afraid to show your characters wearing clothes that hang in shreds from their starving, wiry frames. Too many comic artists these days draw all their characters in tight, form-fitting clothes. This may be done in an effort to accentuate their characters' perfect bodies or out of a fear of drawing clothing. Trust me, clothing is hard to draw. Getting all those folds and wrinkles in there without losing the shape of the figure underneath isn't easy. But, like anything else, it can be learned with practice.

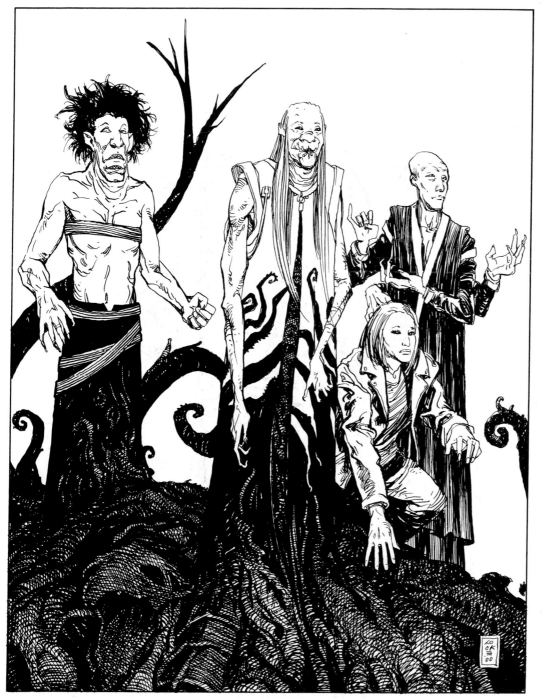

The Gang's All Here

At least two of the people in this group might almost pass for normal given the right surroundings, but together their abnormalities—both physical and sartorial—are magnified. The result: a mean and menacing gang.

The Final Gross-Out

Remember, horror is supposed to make the audience feel disturbed, frightened, revolted, even grossed out. And the characters in your comic book represent the horror you are trying to create. So think about the things that gross you out, the things that you find deeply disturbing, and incorporate them into the characters you draw. Physical deformity is a good one. Uncontrolled drooling is another. Extreme obesity. Skin diseases. Even something so subtle as an off-center eyeball. Think of the things that "get" you. Chances are, if your characters creep you out, they will have the power to creep out other people as well.

Like in *Night of the Living Dead*, when the sheriff described the Zombies by simply saying, "Yep. They're dead. They're all messed up." Just think of your horror characters as "all messed up" while you're drawing them, and they'll turn out fine.

Man-Spider

Funny thing about science. A bite from a radioactive spider might transform you into a hero with super athletic capabilities . . . and then again you might mutate into the town freak for life. Vince Locke's shadowy arachnoid is a good example of "less is more": It has been left to the imagination of viewers to conjure up the most disgusting details they can think of.

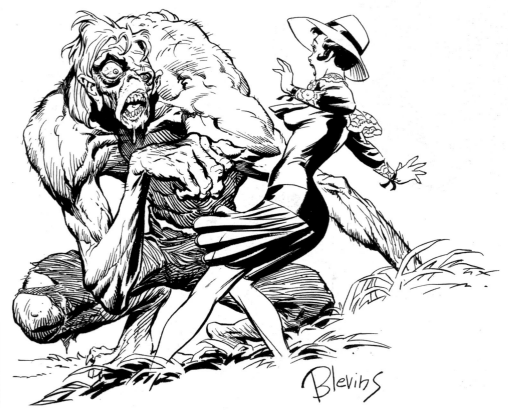

Brett Blevins's Ogre

Nothing offsets the horrific like juxtaposing it next to real beauty. The ugly gets uglier and the beautiful gets more stunning. It is up to you as the creator to decide if beneath the deformed exterior beats a heart of gold, as in the cases of *Beauty and the Beast* and *The Hunchback of Notre Dame*, or if your best bet is to grab a torch and head up a lynch mob.

Mitch Byrd's Multiple Heads

I know two heads are supposed to be better than one, but this is ridiculous!

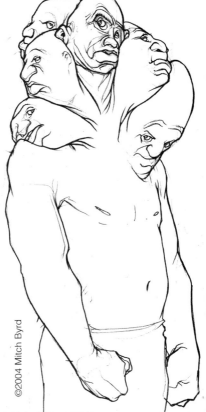

Ix-Tab

Vince Locke is a master draftsman; he can illustrate the realistic and fanciful with equal skill. This figure's dreamlike appearance, while not strictly horrific, is definitely unnerving, an askew view of what might lie on the other side of sleep or possibly in an alternate reality just a few doors down from our own.

Oranesh

The few hints of humanity Vince Locke has given this monstrosity make it far scarier than if it were just a shambling blob of indistinguishable shapes.

THE DEAD AND THE UNDEAD

Vampires

"The blood is the life."
—BELA LUGOSI, *Dracula* (1931)

Vampire legends have been around for thousands of years, and accounts of undead creatures who drink their victims' blood can be found in the folklore of countries all over the world. The vampires in most of the European tales have the ability to change into bats, wolves, and clouds of mist, as well as the powers of hypnotism. Bram Stoker's Count Dracula had to rest during the day in a coffin filled with dirt from his native Transylvania, and the only way to destroy him was to drive a stake through his heart while he was still in the coffin or keep him from his resting place past dawn. Other methods of destroying vampires included beheading, setting them on fire, and stuffing their mouths with garlic. Historically, vampires were supposed to fear holy water and the cross, but vampires these days, like those in Ann Rice's novels, are impervious to both.

To draw any vampire character, start by posing your basic, bare-bones stick figure, then build it up with simple geometric shapes. All fancy details come last.

Classic Count—I

Even when drawing a character whose body is partially hidden by a costume, it is important to draw the entire figure when doing your initial pencil layout. The Count is a perfect example. Much of his body is completely obscured by his long, flowing robes. This does not mean you don't have to draw his entire body. You do. Nobody else will see it in the final illustration, but it's still important for you, the artist, to know exactly where the entire body is when planning out the basic figure drawing. Why? Because it will ensure correct proportions, and will also allow you to draw the wrinkles and folds in the robe in a way that realistically looks like there's a humanoid form inside it.

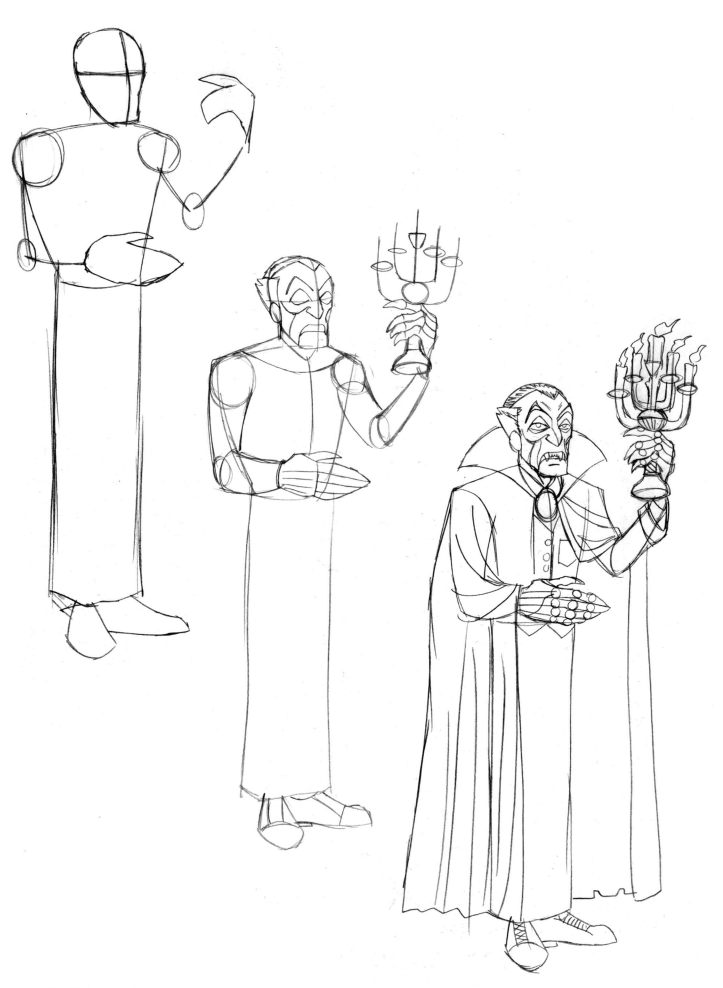

Classic Count—II

The earliest vampires found in literature were not at all like the suave, soft-spoken character played by Bela Lugosi in Universal's *Dracula*, but Lugosi's version was the standard for decades. If it's a the "classic" Dracula you want, it is important to keep the personality of the character in mind. He wears a tuxedo. His hair is perfect. He's got that nice, long cape. He's about as gentlemanly as a monster can get. So keep your lines clean. Keep the edges of that cape straight. As always, begin your drawing by laying out ovals for the head, torso, and pelvis. Once you have the major forms positioned correctly, everything else will fall into place.

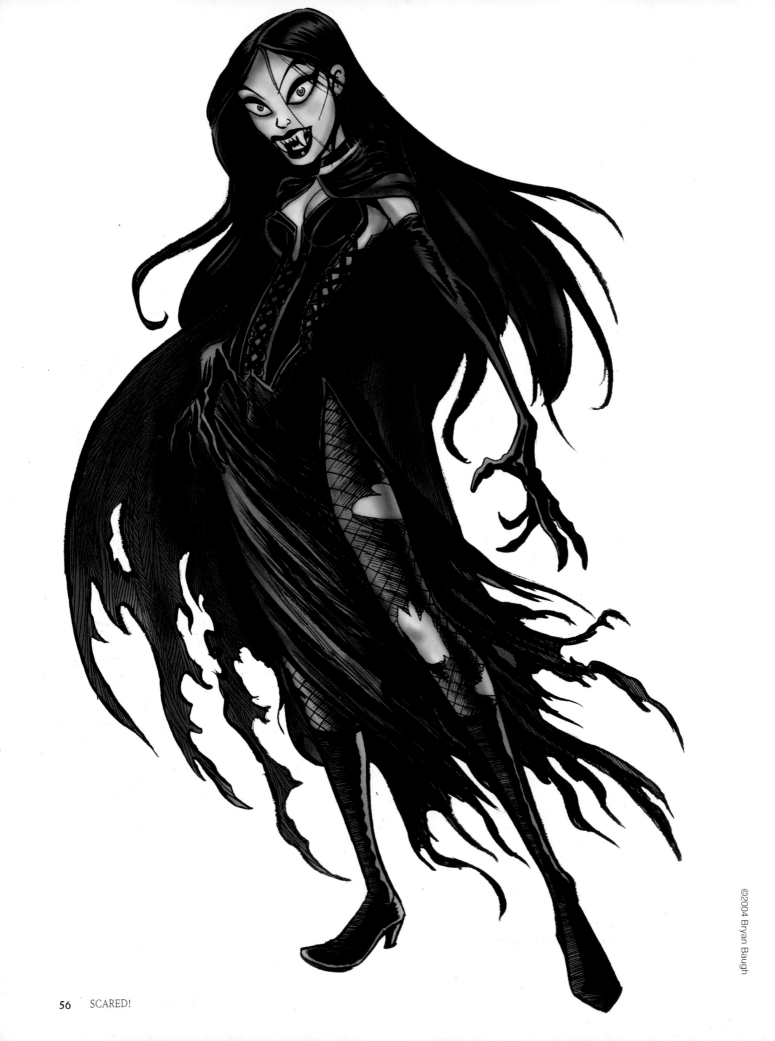

SCARED!

Vampiress

A pretty face, hypnotic eyes, and a nice figure. Too bad she's a bloodthirsty undead thing who just stepped out of the coffin. Just because something or someone is a monster doesn't mean it has to be horrible. If you saw this beauty across a crowded room you'd probably want to go over and meet her. Only when you got within striking distance would you realize your folly. When drawing this beauty, accentuate the finer qualities of the female form—in a word: curves!

Vampire Bat

Vampires have the ability to transform themselves into several different forms: a pack of rats, mist, a wolf, or their most popular alternative form, a bat. Depending on the vampire's inclination it can turn itself into a normal-sized bat like one you might find in the attic, or an enormous half-man half-bat winged terror.

Vampire Slayer

Depending on what you read there are numerous ways to do vampires some serious damage. You can put wooden stakes in their hearts, force them into sunlight, cut off their heads, burn them with fire, paralyze them with religious icons, douse them with holy water, repel them with garlic, or attack them with weapons forged of pure silver. Reports vary, so skilled vampire hunters like this lass here, by Brett Booth, make it a point to be well-versed in the art of hand-to-vampire combat. When hunting the undead it is best to take a page from the Boy Scout training manual and "always be prepared."

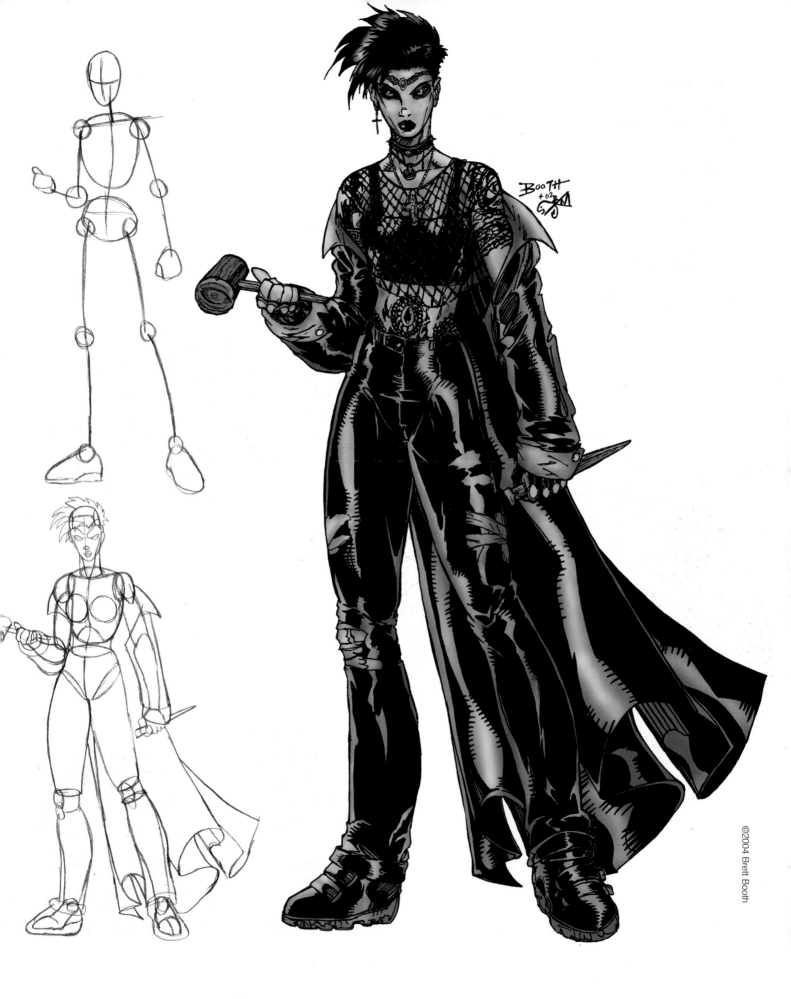

Nosferatu

Nosferatu, a 1922 vampire flick directed by F. W. Murneau, is considered by many critics to be the definitive cinematic portrait of a vampire. There is nothing debonair or suave about the vampires in this film, who must sleep in coffins filled with dirt from graveyards in which are buried victims of the Black Death. The steps involved in creating this horrid creature, however, are the same as the ones used for the classic versions. First draw in all the body parts, and only at the end cover them with the tattered, rotting cloak.

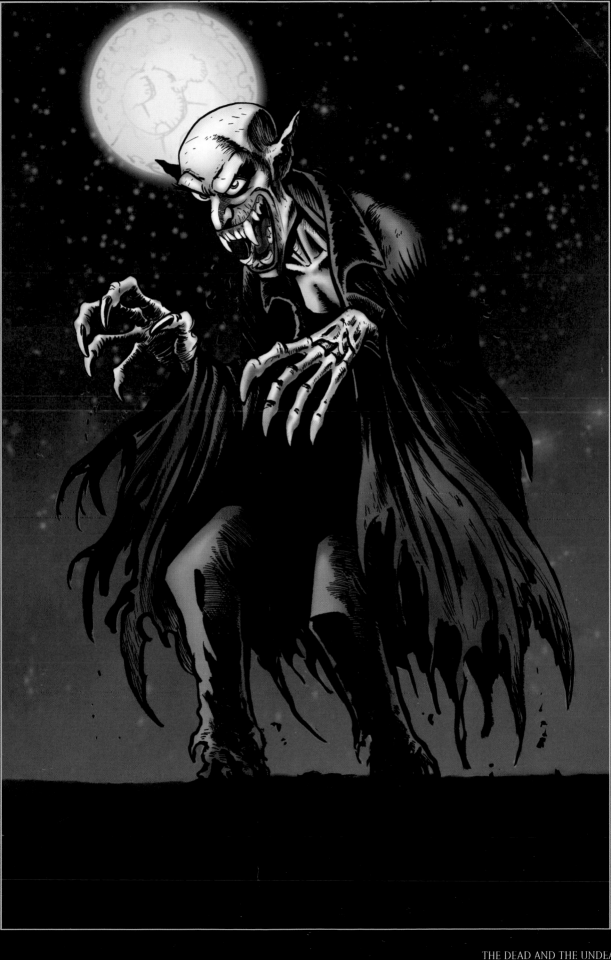

Ghosts

> "He that runs races with goblin troopers
> is likely to have rough riding of it."
> —*The Legend of Sleepy Hollow*

Since the dawn of civilization, every culture has had stories about the spirits of the dead coming back to haunt the living. The question is, Do you believe in them or not? Maybe a better question is, Can you come up with ghost characters that will make your *readers* believe in them?

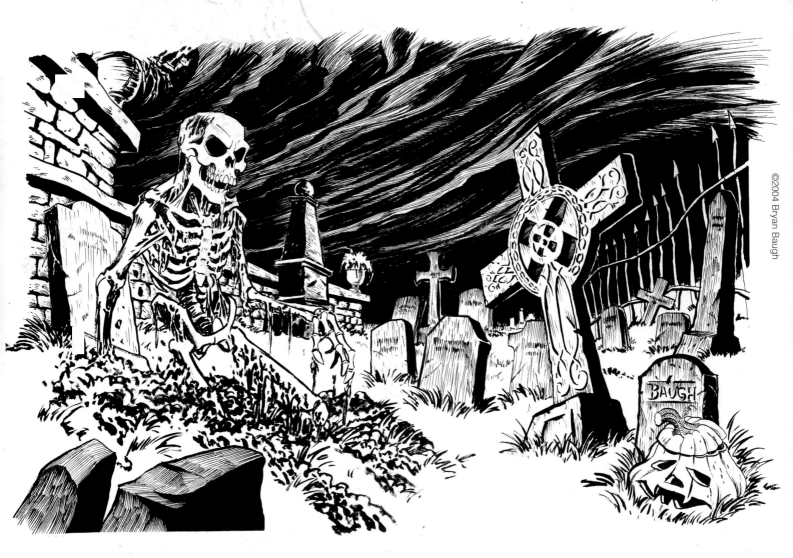

©2004 Bryan Baugh

You Can't Keep a Good Man Down

Ever wonder why cemetery gates are locked at night?
It's not to keep the living *out*. It's to keep the dead *in*.

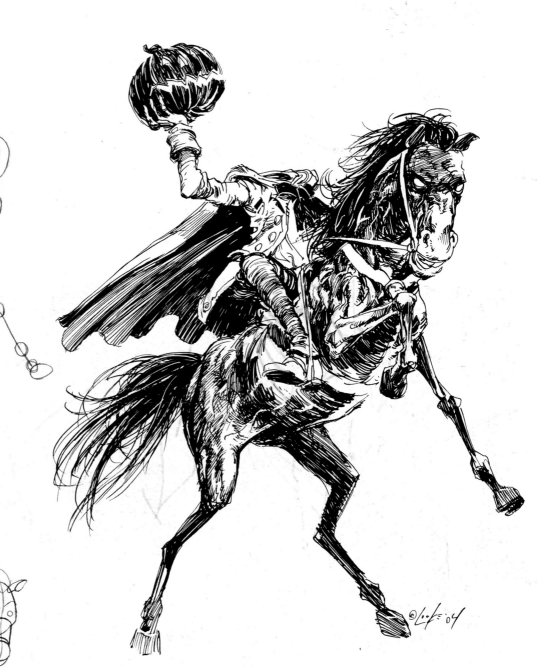

Vince Locke's Headless Horseman

One of the earliest American horror stories, *The Legend of Sleepy Hollow* by Washington Irving, tells the story of Ichabod Crane, who meets a gruesome end at the hands—or rather the head—of the ghost of a Hessian mercenary whose head was blown off by a cannonball during the Revolutionary War and who rides out nightly with murderous intentions. Horses are notoriously hard to draw. Start with a stick figure and add a series of circles, as shown, then connect them with cylindrical shapes. Notice how emaciated the horse is in the finished drawing—the perfect mount for a malevolent ghost.

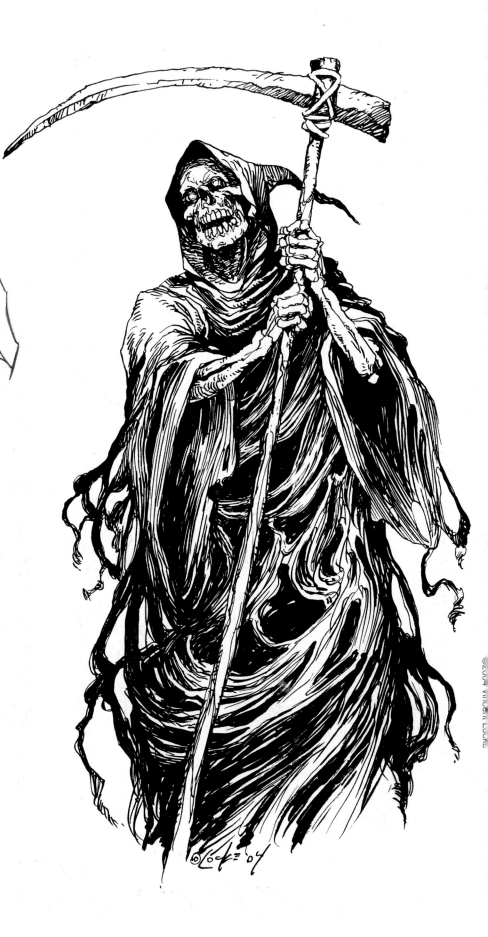

Vince Locke's Grim Reaper

The living incarnation of death, he is always there, always waiting for another harvest of fresh souls.

Zombies

"Yeah, they're dead. They're all messed up."
—SHERIFF MCCLELLAND, *Night of the Living Dead* (1968)

Zombies are truly one of the most fun, darkly humorous, and disgusting monsters to draw because they can appear in so many different forms. A zombie can look like anything from a more or less normal human with pale skin and sunken eyes, to a walking skeleton, to a rotting corpse at any stage of decomposition.

In the Wrong Place at the Wrong Time

A pretty girl and a graveyard full of zombies. Everything a growing boy needs! Notice Bernie Wrightson's use of brown ink, which blends more seamlessly with the painted colors than black ink would.

Fresh from the Grave

He's rotted, covered with mud, and half-eaten by bugs.
This guy waited about twenty years before crawling out
of his grave. When drawing zombies, you definitely want
to exaggerate the scrawniness of their arms and legs.
Make his limbs just a bit longer and skinnier than they
should be, so it looks like there's nothing but bare bones
under those ragged clothes. Another nice touch is to
give the suggestion of clumps of dirt, bits of clothing,
and rotted pieces of skin falling off of him. You can add
these very quickly and easily by splotching little spots
of ink all around the zombie with a small paintbrush.

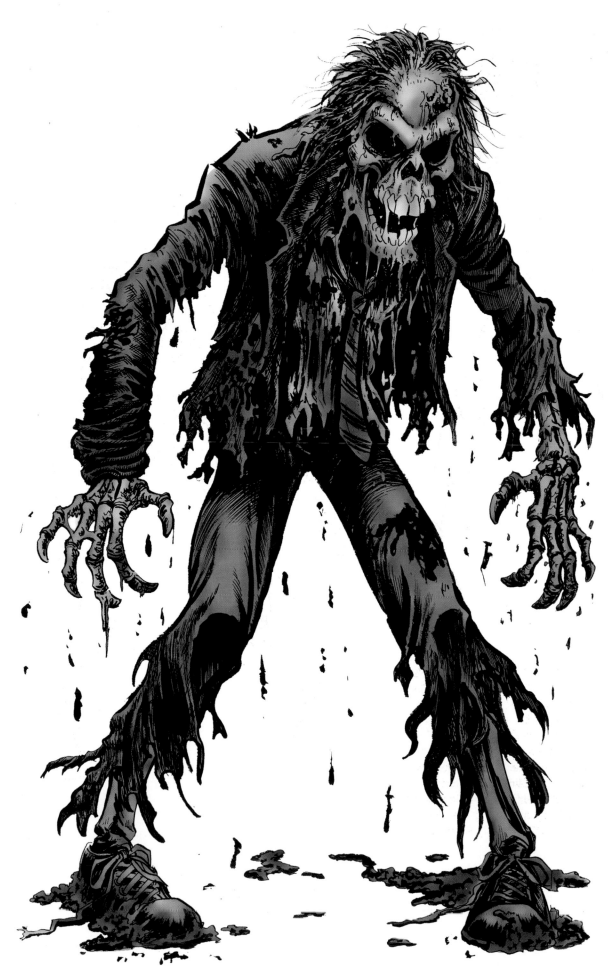

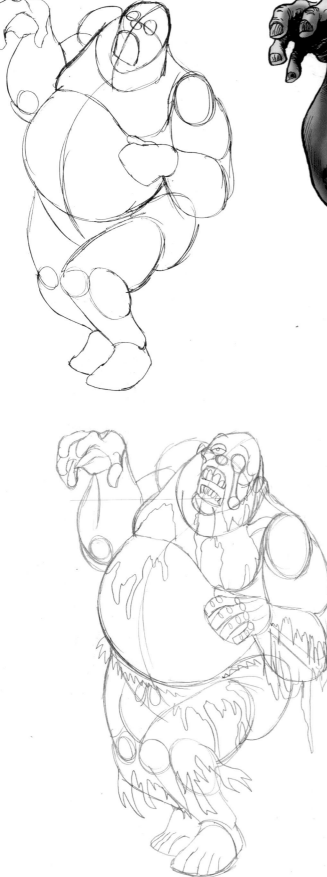

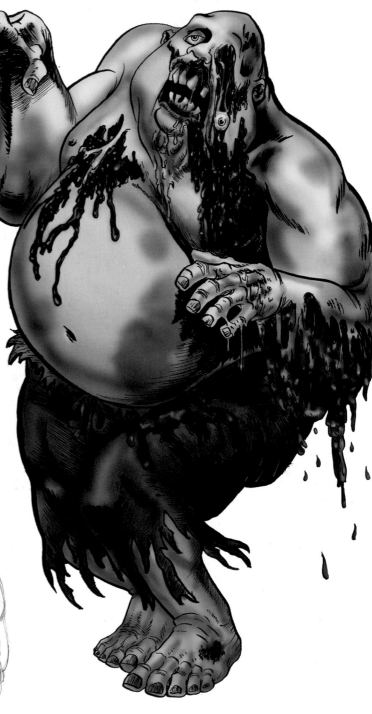

Fat but Still Famished

Was he always this way, or has he just been eating too many humans since he rose from the grave? You may not believe it, but a stick figure is still the best first step for drawing this guy. Just make the basic body shapes appropriately bigger and rounder than you normally would. Go ahead and exaggerate. Make him as bloated and hideously disgusting as possible.

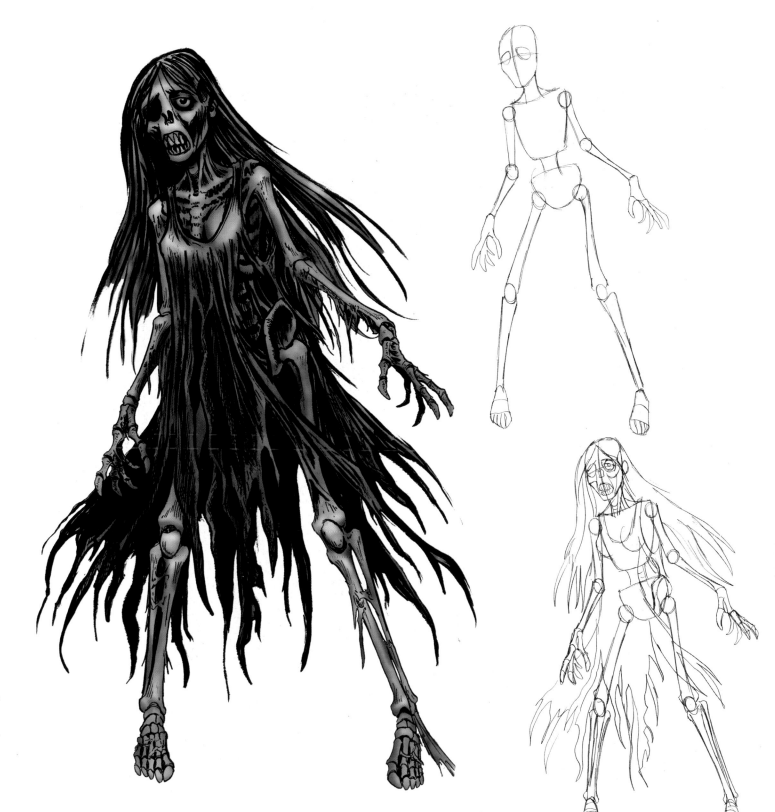

Female Zombie

Yes, sometimes even once-beautiful women can return from the dead. Proportionally speaking, a woman's skeleton is smaller in frame than a man's skeleton. Keep this in mind when drawing your female zombie. Even though you're going to cover most of her bones with long, trailing rags of clothing, give her a narrower ribcage and pelvic area as well as smaller hands and feet than you would a male corpse. Giving her long, glossy hair conveys the impression that she was once beautiful. She has sad eyes and a down-turned mouth. An unsteady, slightly leaning pose creates the sense that she's aimlessly drifting in the wind.

Burned Alive

If on some night you happen to hear dragging footsteps and smell something like sizzling rancid bacon coming up behind you, watch out! Let me tell you my very fast, fun technique for drawing charred human flesh. Once again, start out by drawing a bare-bones human skeleton in whatever pose you want. When you are ready to finish the drawing in ink, toss your pens out the window. For this technique, you're going to need a paintbrush with a fine tip and a bottle of India ink. Dip the brush in the ink and make small, black blotches all over the skeleton's body. Allow random areas of white to show through between blotches so it has some sense of glistening, moist, crispy surface texture. Don't go too fast. Think it through, applying the heaviest amounts of black to the parts of the body that would naturally be in shadow. Looks pretty gross, huh? Now I want you to remember this the next time you're eating fried chicken.

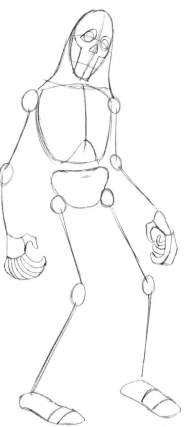

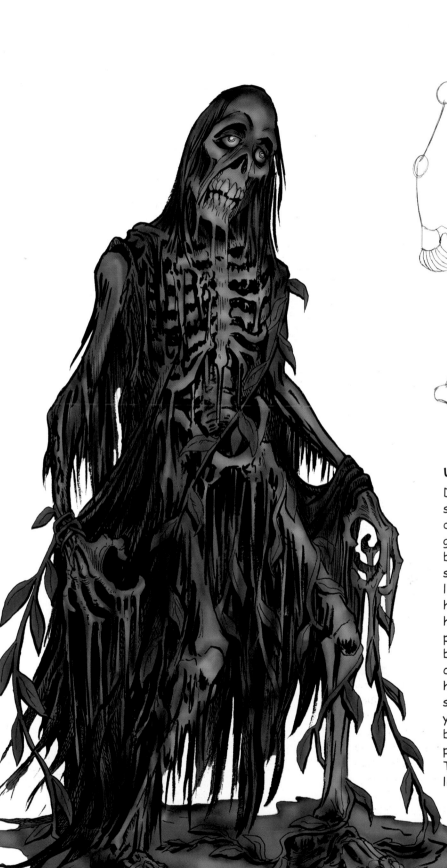

Unfresh from a Watery Grave

Dripping with saltwater, tangled in seaweed, and stinking of dead fish, the drowned zombie arises from its watery grave in search of surfers and beach babes to consume. Vertical linework is the secret to drawing this guy. Note how many lines in this illustration seem to run down his body: his hair, the rags hanging from his limbs, the water that seems to be pouring down and off of him. It's nothing but a series of vertical lines, but it creates the look of an undead thing that has just climbed out of the surf. It's a simple technique really. Once you've got your drawing of the figure in place it becomes a simple matter of dragging your pen or ink brush down the zombie's body. Try to make this effect work with pencil lines first before doing it with ink.

Slimed!

As if being a rotting undead thing from the grave weren't gross enough, he had to be dripping with slime, too! Don't let all the detail scare you out of drawing this guy. There's really nothing to it. If you can make a basic raindrop shape (most artists can by the first grade), and elongate it, then you've essentially mastered the fine art of drawing drips of slime. Now just draw a few million of them all over any basic skeleton, and you've got a slimy zombie.

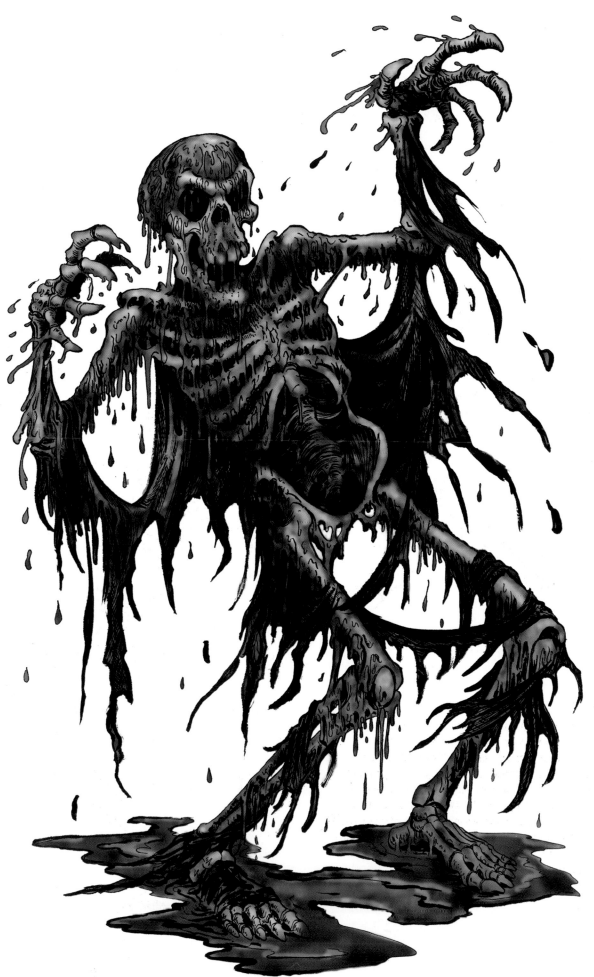

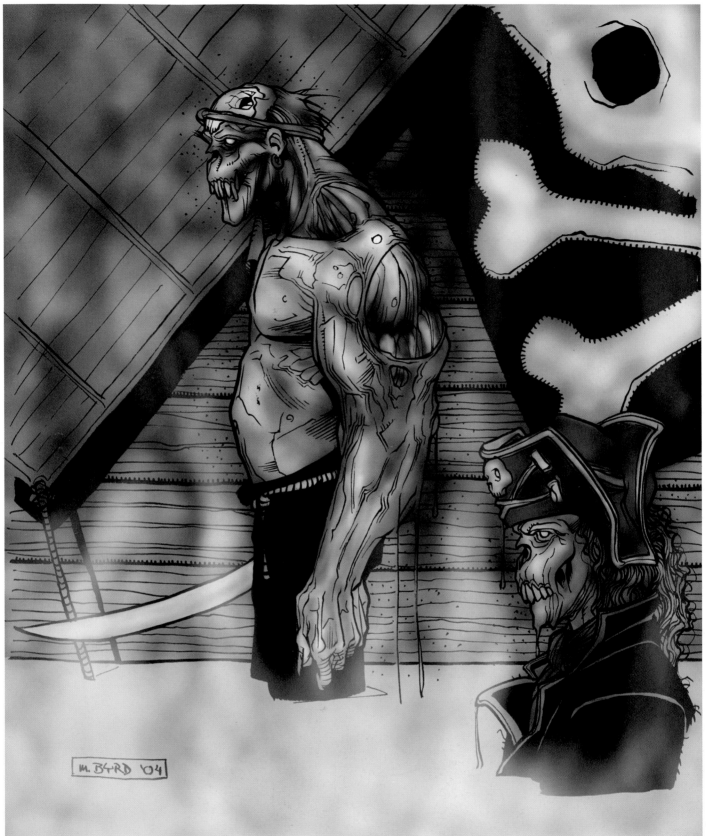

Byrd's Buccaneers

Zombies are the jacks of all trades in the horror industry. There really aren't too many roles these refugees from the graveyard can't play. Dress them up as pirates, clowns, cowboys, astronauts—they'll take whatever you throw at them and keep on coming.

Mummies

"Death is only the beginning."
—Imhotep, *The Mummy* (1999)

In ancient Egypt, much work went into the preservation of the dead. Too bad it wasn't enough to keep them from coming back to life!

Boris Karloff was the first film actor to play the high priest Imhotep who, as ancient legend had it, was buried alive by Pharoah but returned to walk the earth centuries later when some foolish archeologists set the curse inscribed on Imhotep's sarcophagus in motion by opening it.

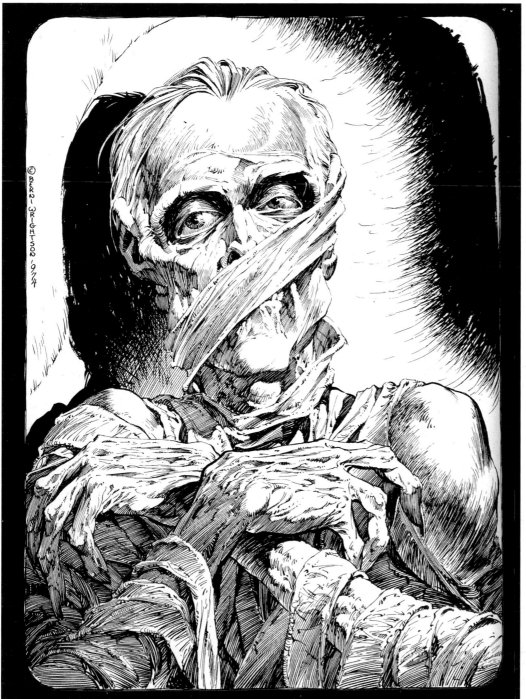

What is Bernie Wrightson's relatively undecomposed but undeniably malevolent mummy looking at? Possibly, a pharoah's servant who is getting him ready for the afterlife. And possibly some fool who came along centuries after he was entombed and thought it would be a good idea to unwrap him.

Traditional Mummy

The stick figure in the first step here sets up the right look for an emaciated mummy. The length of his arms, and especially his legs, is highly exaggerated, which makes him appear taller. To give your mummy a long, thin, skeletal head, start with an oval that is longer and narrower than that of a normal person.

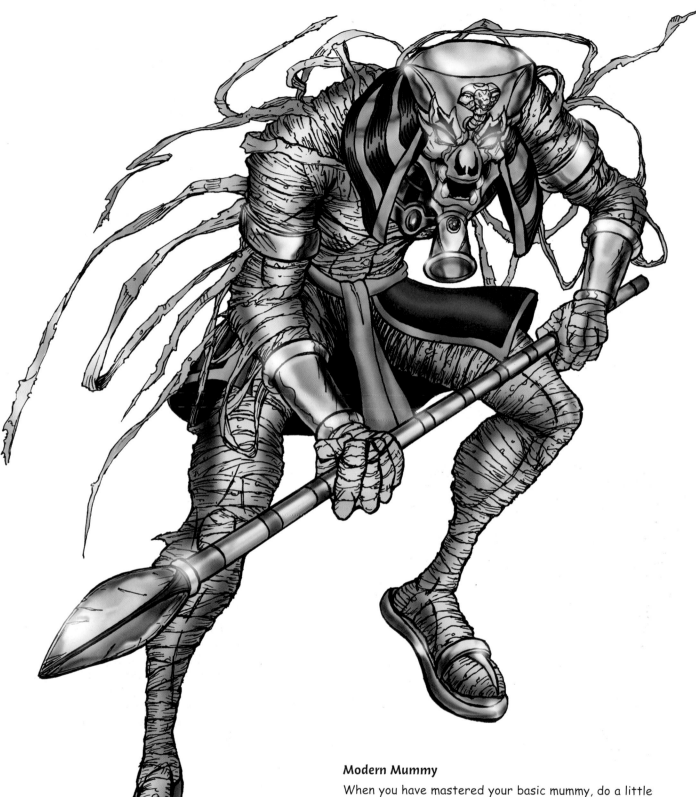

Modern Mummy

When you have mastered your basic mummy, do a little research into Egyptian history and see if you can unearth some accessories worthy of a resurrected pharaoh or high priest. In the horror genre everything has been done at least once before, so your job as an artist is to look for an inventive way to put a new twist on an old idea, like the headset on this guy.

WEREWULVES

> I'm going to *transform* him, and unleash the savage instincts that lie within.
>
> —Dr. Alfred Brandon, *I Was a Teenage Werewolf* (1957)

Werewolves of myth are humans who shape-shift into wolves at certain times. The many legends about werewolves give varying accounts of their specific powers, their weaknesses, and their appearance. Some werewolves can change into animal form only when the moon is full. Others can change at will. Some retain recognizable human characteristics, while others are all wolf. In most cases, werewolves are savage, powerful monsters with an insatiable hunger for human flesh. They are extremely fast-moving and very difficult to kill. And, oh yes—if you get bitten by a werewolf, you will become one yourself.

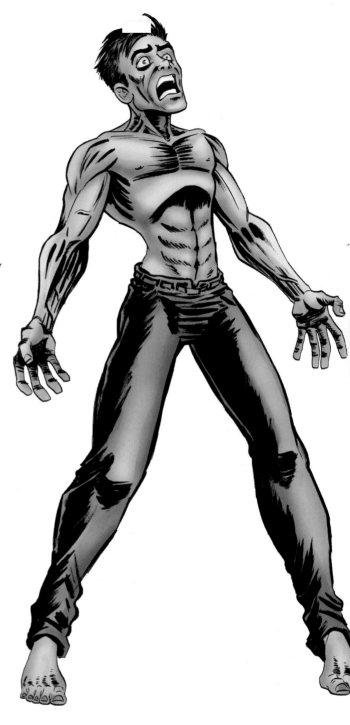

Lycanthrope
Bernie Wrightson's werewolf chows down on a typically messy meal.

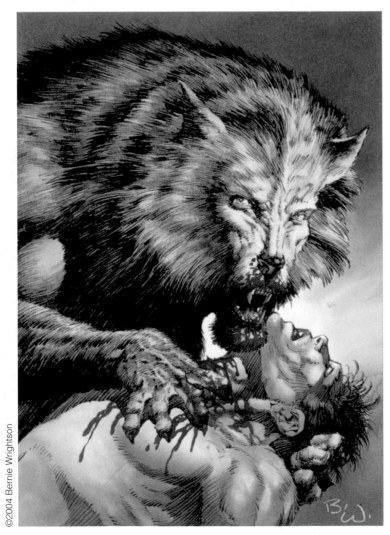

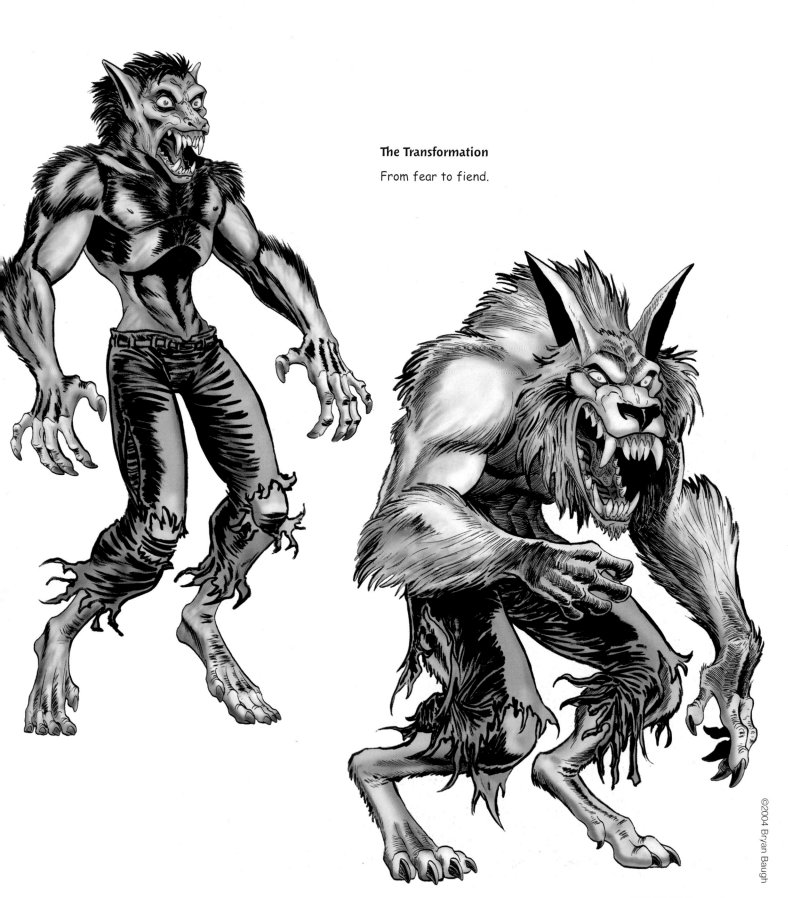

The Transformation

From fear to fiend.

It's Fun to Be a Werewolf!

When drawing this werewolf, be sure to make his upper body very large and bulky as compared to his lower body. The head is based on a normal wolf head with all of the prominent features (snout, teeth, ears) elongated to make him look crazier. When drawing any kind of monster, always try to imagine what it might be thinking. You may be surprised at how much of this will come through and give your monster personality. The idea for this character is a werewolf who *likes* being a werewolf. There's a certain eager, mischievous expression in the eyes, brows, and corner of the mouth. He is simply delighted with his transformation and can't wait to get out there and hunt some humans.

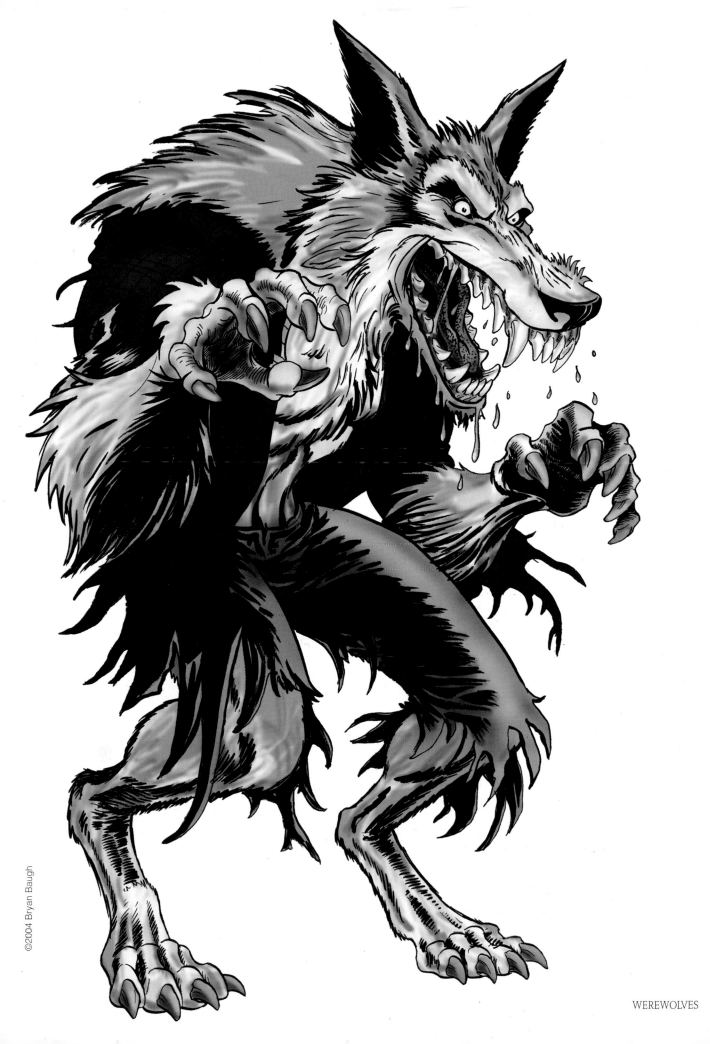

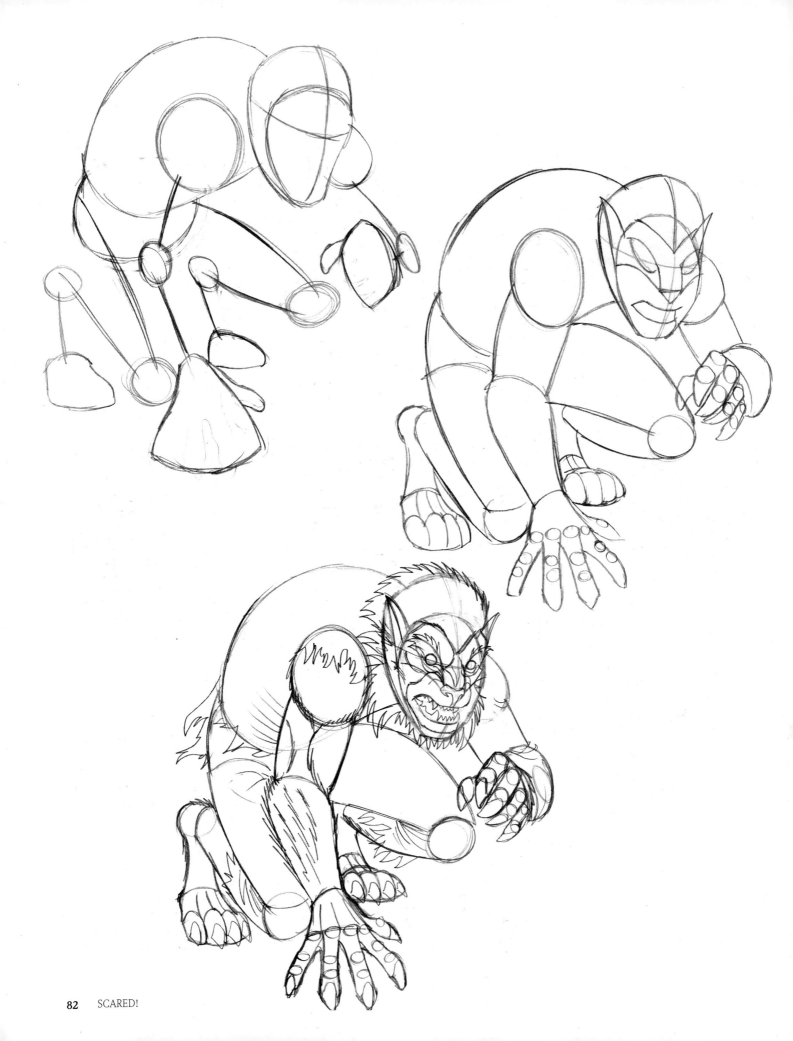

SCARED!

The Classic Pose

The body of this classic wolfman is more human than wolf, but he has a snarling wolf face, long ears, sharp teeth and claws, and fur. You can lay this character out by starting with a simple human stick figure, in a crouching position. Then build up the forms with ovals and simple shapes the way you normally would when drawing a regular person. When you get to the face, stop thinking human and start thinking wolf. The final step is of course to add on all the surface detail: the texture of his pants, the ragged edges of his pants and shirt, fur (just draw in a series of loose, short lines over the outline of his basic form), razor-sharp claws and teeth.

He's All Wolf

In some stories, the transformation was from man into a monster-sized wolf, cursed to run around on four legs, devouring anyone it came across. For this one, you've got to think animal. We're no longer in the realm of drawing modified humanoid forms. This thing is a big, exaggerated, monster-wolf, plain and simple. Make his head, chest, and hips bigger, broader, and more muscular than any normal, living wolf. Give his front and back legs more thickness, and his paws greater width. Don't bother trying to draw a realistic wolf-face. This is a monster, a beast of supernatural evil. Show that in his expression. Make his eyes stark, staring mad. His mouth should be a huge, slobbery maw with enormous teeth.

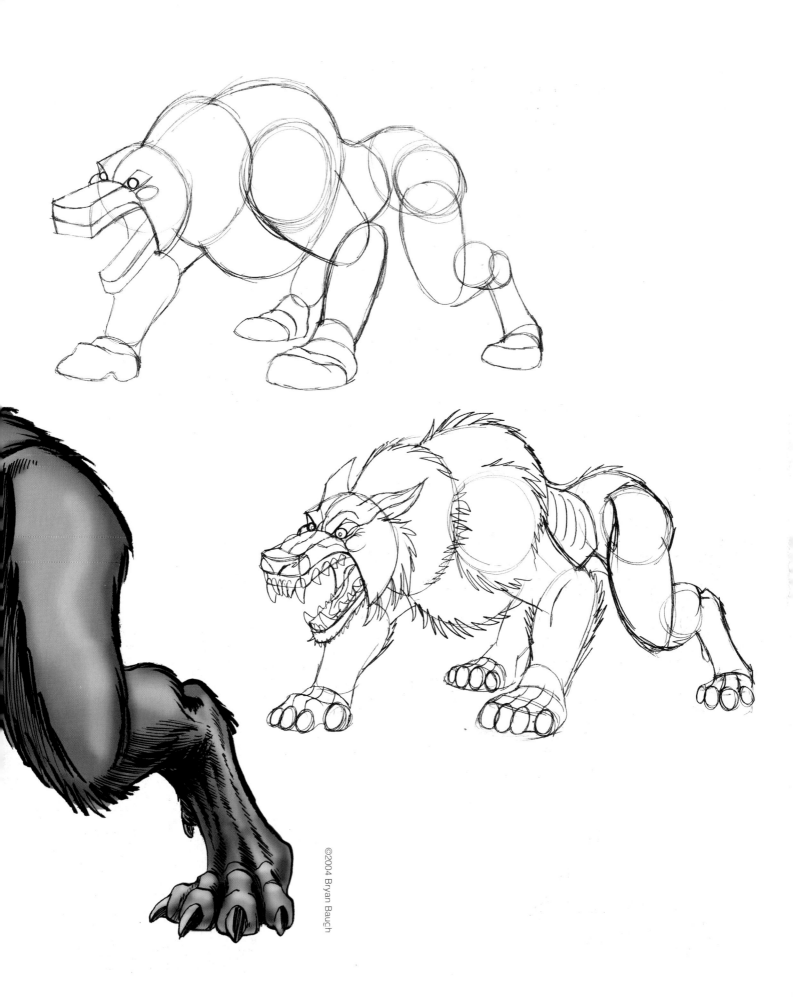

©2004 Bryan Baugh

HUMAN MONSTERS

"Who will survive and what will be left of them?"
—Tagline for *The Texas Chainsaw Massacre* (1974)

Sometimes, evil human beings are the scariest monsters of all.

One of the most famous fictional human monsters is The Phantom of the Opera, a character created by the French novelist Gaston Leroux in 1911. The Phantom's real name is Erik, a master musician of The Paris Opera House, whose face has been horribly disfigured in an accident and who has taken up secret residence in the underground passageways beneath the Opera House. Erik is obsessed with the beautiful young singer Christine Daae, and begins sending threatening letters in which he demands that management make better use of Christine's talents, signing them "The Opera Ghost." When his letters are ignored, Erik commits various murders. He also finds a way to lure Christine into his lair, but, in the end, lets her go. The story, a disturbing combination of murder mystery and Beauty and the Beast–type fairy tale, has been made into at least seven movies. The first was the 1925 film starring Lon Chaney, whose frightening visage was the inspiration for the Vince Locke Phantom shown here.

Freaks

A vintage Bernie Wrightson collection of human horrors.

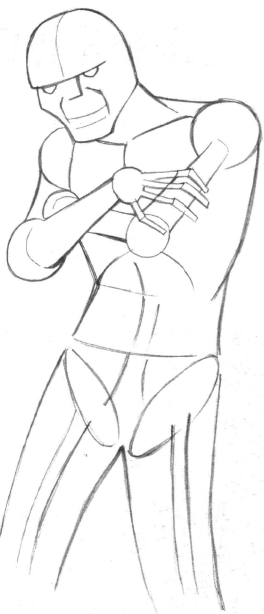

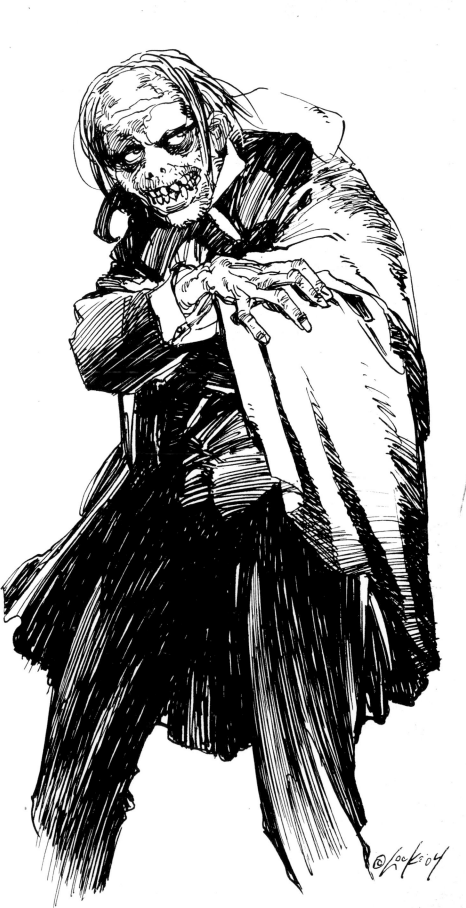

The Phantom of the Opera

Even though the Phantom's left arm and shoulder will be entirely hidden by his cape, the basic shapes are sketched in, so when the cape is added, the cloth will hang exactly right.

Hooded Executioner

Centuries ago, those condemned to death were sent to this guy. One swipe, and off with the head. Of course, if you'd been really, really, evil, he might mess up on purpose and take a few extra whacks at you. There's a lot of careful exaggeration going on in the drawing of this character. The idea is to make him stout, but still very strong and imposing. You want to give him that big fat belly, but you don't want to lose the threat. The solution is to balance the oversized stomach by exaggerating the proportions of his shoulders and arms. Use sharp angles, hard lines, and blocky shapes for those muscular shoulders and arms, as opposed to the soft curve of his flabby gut. Spread his feet apart a bit, too, to give him a weightier stance.

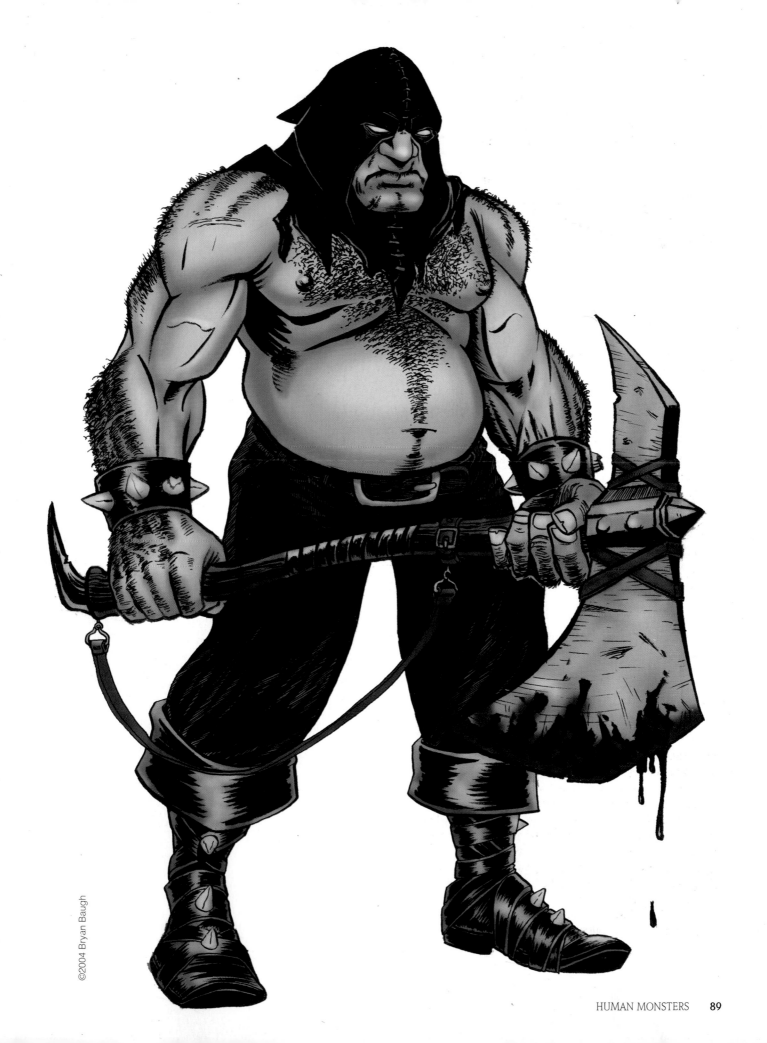

Chainsaw Maniac

Some guys use knives and some guys use axes, but our friend here chose something a little more efficient. In the end, it doesn't really matter what tools you use, as long as you get the job done and have a good time doing it. Drawing this character involves the same challenge as drawing the hooded executioner. The proportions may be less extreme, but it's another exercise in drawing a big, chubby guy who still looks strong and dangerous. What really gives the chainsaw maniac a sense of life and movement are all the torn shreds of clothing flying about, his spiky hair, his leather fright mask, and the droplets of blood spraying off his chainsaw.

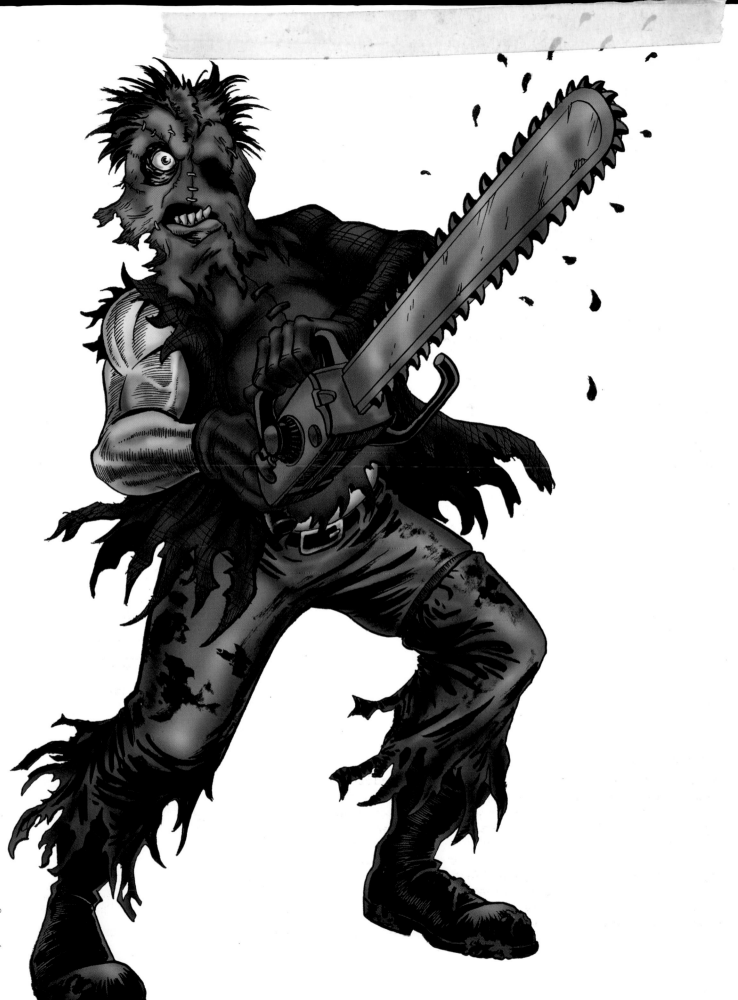

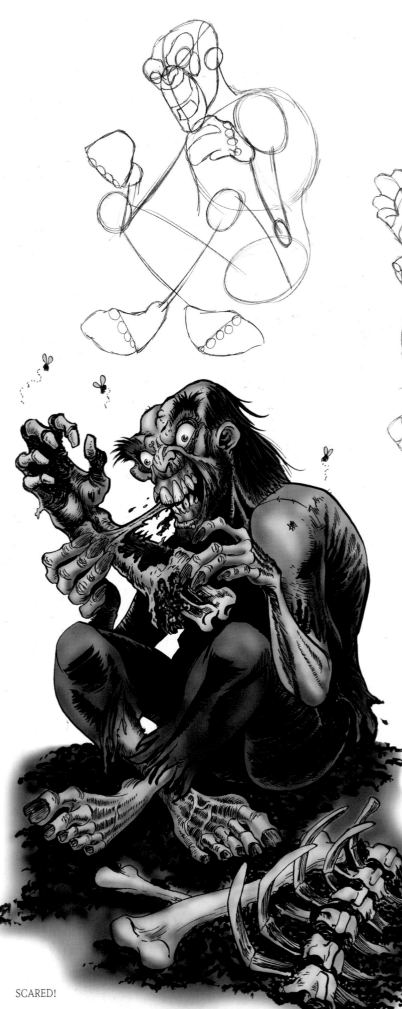

The Ghoul

Ghouls are demented maniacs who break into cemeteries in the middle of the night, dig up corpses, and eat them piece by piece. Hmm. Seems like running out to a hamburger joint would be a lot less work. The tricky part about drawing this guy is his pose. He's curled up, sitting cross-legged on the ground. Don't let that scare you. If you can draw your basic stick figure in this pose, then you can build the appropriate shapes on top of it. Although ghoul guy is a human being, his deformed psyche has left its mark on his dreadful face.

Freak

Chromosome damage, natural or unnatural, can have hideous results. To draw any severely deformed person, start by twisting your stick figure into a completely agonized pose. Then add extra ovals and blobs, which will become grotesque layers of deformed flesh. Make one eye droop lower than the other. Mangle the shape of the mouth, and point the teeth in all directions. Allow one hand and one foot to swell into ghastly, totally inhuman shapes. Here's a chance to take all those rules of anatomy and proportion and throw them out the window, and just have fun, creating a wretched abstract abomination of the human form.

SCIENCE GONE WRONG

"It's alive! It's alive! It's alive!"
—Dr. Henry Frankenstein, *Frankenstein* (1931)

From Mr. Hyde and Frankenstein's monster to Swamp Thing and Doc Ock, monsters created when forbidden science goes wrong have been staples of horror fiction.

In the classic novel *Frankenstein* (1818) by Mary Wollstonecraft Shelley, an ambitious young student, Victor Frankenstein, decides to use the power of science to create life. Although Frankenstein's goal is to help mankind, his experiment goes horribly wrong: the life he creates is a monster, a pathetic, hideous creature. The monster, who is abandoned by Frankenstein, lives only for revenge. He kills Frankenstein's fiancée and other members of his family, and pursues Frankenstein himself to the ends of the earth. The main theme of Mary Shelley's allegorical tale is that trying to play God will, ultimately, lead to evil.

Robert Louis Stevenson's *The Strange Case of Dr Jekyll and Mr Hyde* (1886) also explores the terrible consequences of scientific arrogance. Jekyll, a brilliant scientist with an impeccable reputation, theorizes that every man has both an evil nature and a pure, good nature and that if a way could be found to isolate the evil side, the human race would fulfill its great potential. Unfortunately, the potion he devises works only to physically transform Dr. Jekyll into the murderous Mr. Hyde: the living incarnation of his own primitive, satanic self.

Mad Scientist

His poor parents put him through medical school for *this*?! Drawing the mad scientist is easy. It's just a matter of laying out the basic shapes, designing his smirking, demented face, and getting his hair to look suitably horrible. Then you can have fun putting in all the creepy stuff he has in his lab.

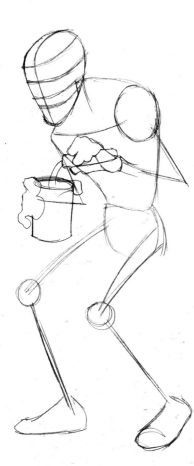
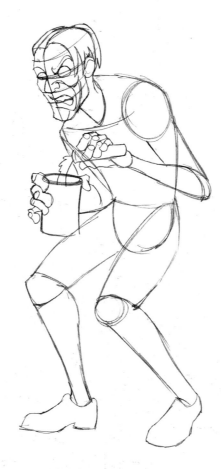

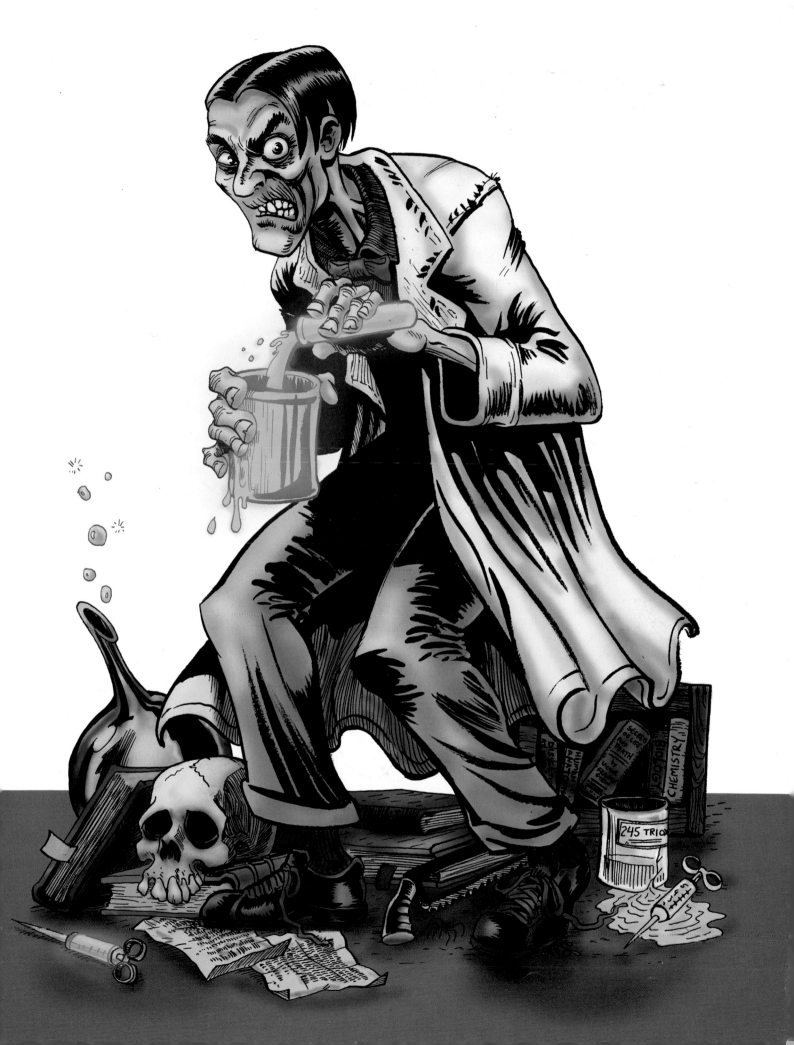

Frankenstein's Monster

When drawing Frankenstein's monster, you must evoke his size, his bulky strength, his corpselike visage, and, of course, his sadness. Give him a large frame, with slightly oversized, blocky shapes for his head, torso, hands, and boots. But make his arms and legs lanky and thin. Give him a gaunt face, hollow cheeks, sunken eye sockets, and heavy, drooping eyelids. It helps to put him in a somewhat unsteady pose, either crouching or hunching. Being made out of a bunch of dead body parts haphazardly sewn together does nothing for this monster's mobility.

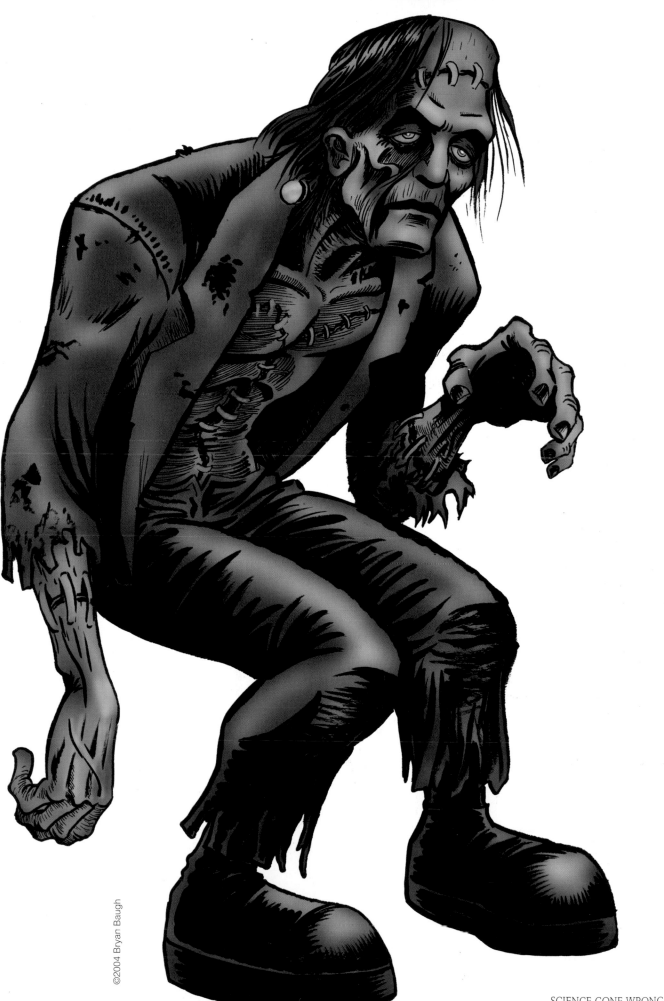

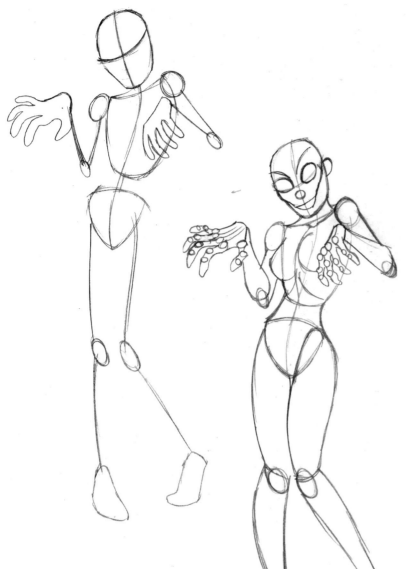
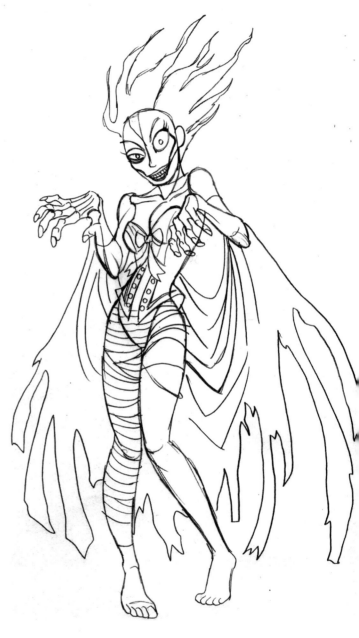

The Bride of Frankenstein

The monster got lonely, so Dr. Frankenstein built this
little number to keep him company. Here's another chance
to draw a pretty girl, but this one you're going to decorate
with jagged stitches, deformed, arthritic hands and arms,
knock knees *and* pigeon toes, and a head of wild, unruly
hair (inspired, unnaturally enough, by Elsa Lanchester's
electrified do in Universal's *Bride of Frankenstein*). The
trick is to retain just a little bit of the cute coquette.
She's got one good eye, a small nose, and a slightly
crooked smile. After all, what's more disturbing—a dead
girl, or a dead girl who is trying to flirt with you?

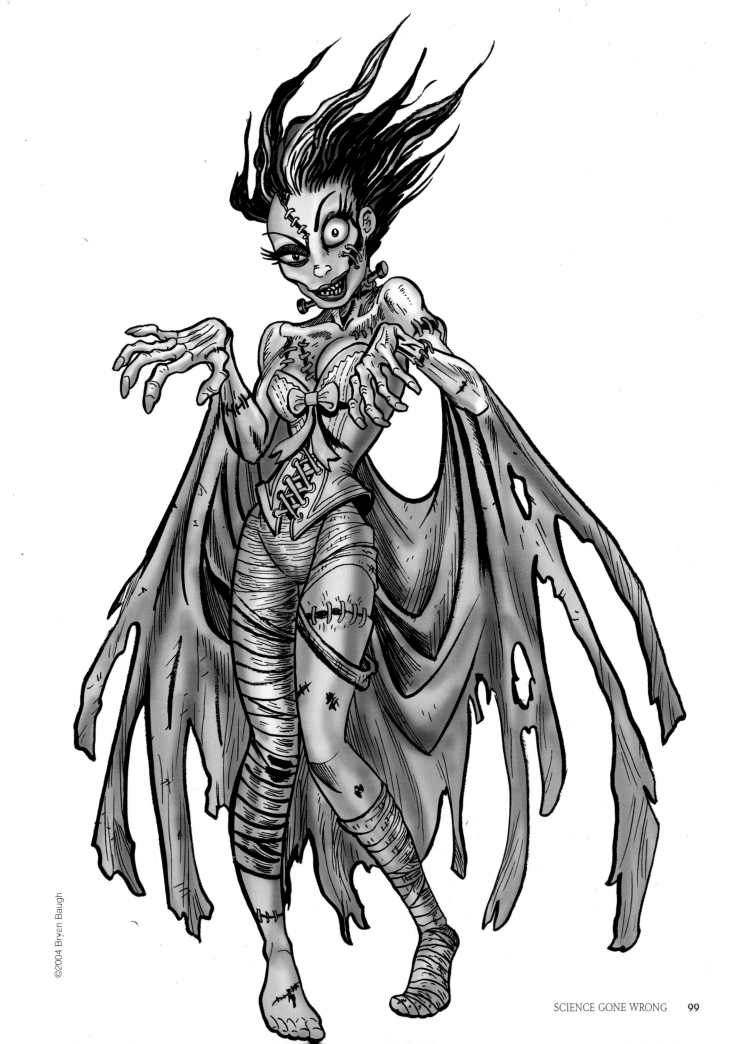

Hunchback

If you want a job as a lab assistant to a mad scientist, you must be short, deformed, slightly stupid—and insane. No one else need apply. When drawing the hunchback, remember that it's still the same basic human figure—you're just squishing it down a little. Give him a large, round head, awkwardly turned to one side; a wobbly, bent-over stance; and distorted arms and legs. The pupils of his eyes are off center as well as different colors and sizes. He drools. Create dirty stains on his clothes using a dry-brush technique. Dip a brush (don't use one of your good sable brushes) in a bottle of ink, wipe it off with a rag until the bristles are almost dry, then press the brush down, with the hairs slightly separated, all over the hunchback's shirt and pants. The ink will come off in uneven patches and smears. Ta-da! Instant filth.

©2004 Bryan Baugh

Mr. Hyde

There are as many interpretations of what Mr. Hyde should look like as there are different films and comics about him. Stevenson's novel does not provide a detailed description, saying only that both face and body of Edward Hyde bore an "imprint of deformity and decay" and that Hyde is evil incarnate. This Hyde resembles an apelike caveman gone stark, raving mad. His huge head and hands and impossibly long arms are sketched in right at the beginning. His cape, which flares out all around him, gives the character a **sense** of life and movement.

Scary Scarecrow

Jack Pumpkinhead is an amiable character in L. Frank Baum's Oz books who is brought to life by mistake when a small boy sprinkles the forbidden Powder of Life on him. This scarecrow was also brought to life by forbidden magic, but he is anything but amiable. Partnering with a vulture-like crow, he's ready to take off on those monstrously long legs in search of victims.

The Creeping Brain

A fresh brain, the right chemicals, some hard work, a little love, and any mad scientist can make one. To draw the Brain, start with a large oval shape for the brain itself, then draw a long, curving line for the spine/tail. Add simple lines for the eyestalks and jointed, bony insectoid legs. Add simple lines to position the eyestalks and the jointed, insectile legs. Draw in teeth and tentacles. You'll need to find a good reference before you tackle the details—the texture of the brain lobes and cerebellum (the structure at the lower left of the brain) and the vertebrae. The eyestalks? You're on your own!

The Fly

This is a classic case of what can go wrong when a fly gets into the old gene splicer ointment. Leaving one hand and arm, and upper thighs, still basically human in appearance intensifies the horror of what has happened to this guy. A giant fly is scary. A giant fly who was once a human being is *really* scary. Notice the variety of shapes used to build this character: circles, cylinders, upside-down bowling pins, even crescents (the pincer feet). The final linework is also extremely varied, and conveys just how complex—and horrible—this creature is.

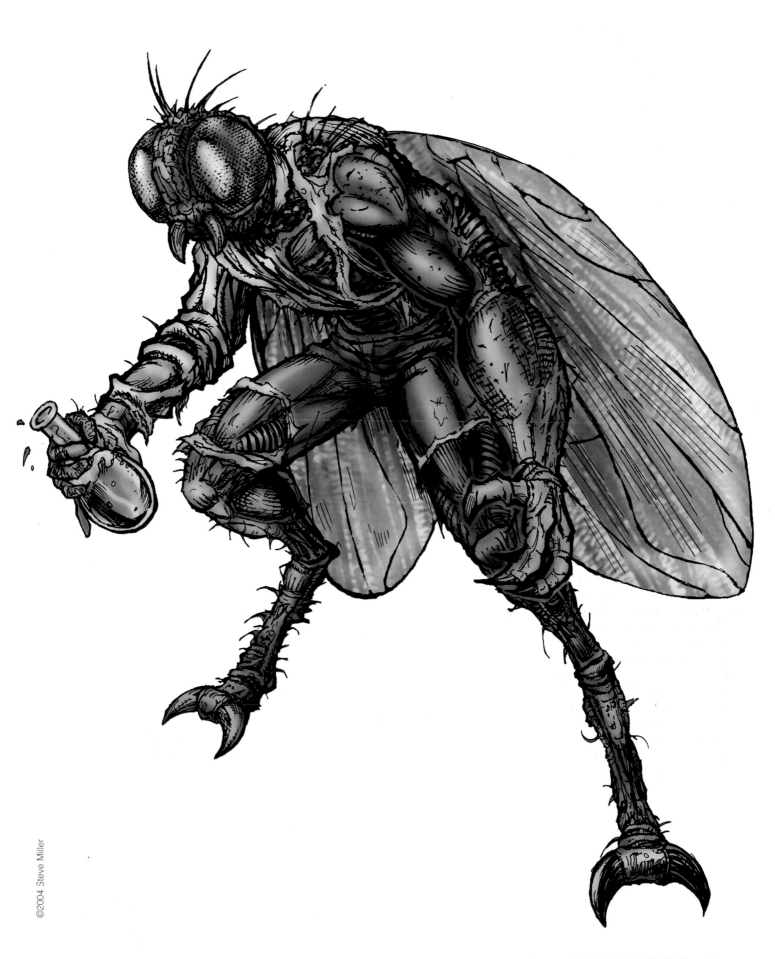

It Came from the Toxic Swamp

I guess it wasn't such a good idea for those botanists to dump all the waste from their top-secret experiments into a nearby swamp—especially a swamp that already had a corpse in it. When drawing a character like this, don't get caught up in contemplation of all the gnarly surface details you need to render. As always, there has to be a solid figure underneath to build off of. Before you start rendering any of the fun fauna and plant textures make sure you have properly drawn the anatomical shapes beneath.

IT CAME FROM OUTER SPACE

> "Keep behind me. There's no sense
> in getting killed by a plant."
> —*The Day of the Triffids* (1962)

Most people believe there are intelligent life forms on other planets. And, given our own planet's history, a lot of us are probably more than ready to believe that whoever—or whatever—is out there is probably hostile. (How else to explain the mass hysteria caused by Orson Welle's famous 1938 radio broadcast of H. G. Wells's *War of the Worlds*?) The best sci fi/horror fiction taps into those beliefs, finding new and creative ways to infect us all with a bad case of xenophobia—fear of The Other.

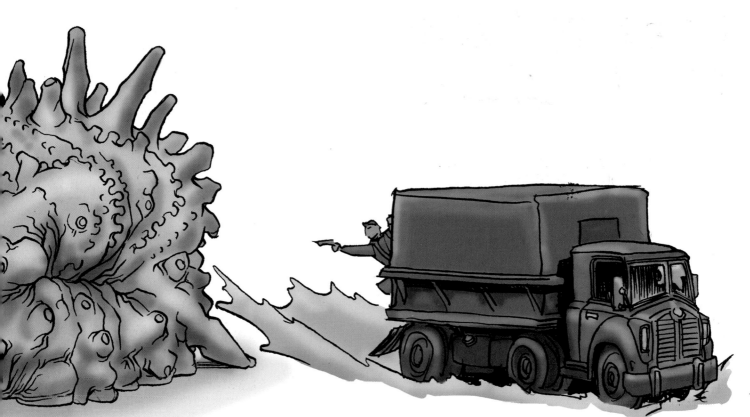

Space Spore

It may look like the offspring of a sea sponge and a dog's squeaky toy, but don't let its appearance fool you. It certainly hasn't fooled the sharpshooter in the truck. What Mitch Byrd has drawn here is an A-1 close encounter of the worst kind.

Space Glob

This space pudding is a load of fun to draw. As long as you keep the ooey-gooey factor high, you can't go wrong. Whoever said "There is always room for Jello" probably never had one try to eat him.

Space Mutant X

Xenophobia: fear of new places, fear of new people, fear of an eight-foot-tall being from outer space with giant pincers where his hands and feet should be and a pulsating exo-brain.

Alien Attacker

They say that in space no one can hear you scream. Obviously they never ran into this guy. One look and you'll be hitting high notes an opera tenor would be jealous of. Textures are an important part of any character design. Monsters should not only be menacing, they should also look like they would be very unpleasant to touch. Scales, slime, goo, and hard or sharp armor like an insect's are all good textures for the horrific.

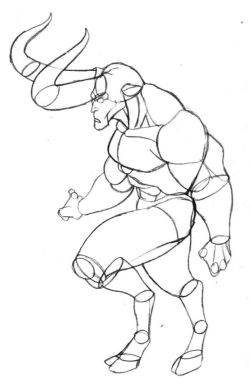

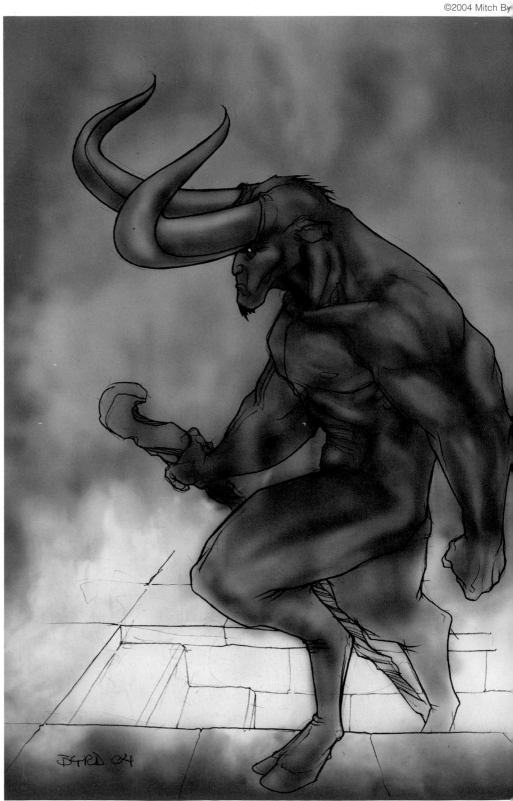

From the Planet of the Demons

There is no reliable account of how the traditional image of Satan evolved. The Bible, in Revelations, describes the Devil as "a great red dragon with seven heads and ten horns," and most scholars agree that the Medieval concept of Satan as a horned, cloven-hoofed being was in part based on the Greek God Pan. We can probably thank Dante for the pitchfork: *The Inferno* describes horned demons using them to drive sinners back into flames and boiling tar. In any case, during the Middle Ages when Satan came on stage in one of the many "mystery" plays depicting biblical scenes, he was a grotesque individual with a red outfit, tail, curved horns, and pitchfork. Drawing a character based on a cultural bogeyman as famous as the Devil, whether it hails from outer space or the bowels of the earth, is a quick way to clue your viewing audience into the character's internal motivations, When drawing Ol' Scratch pay special attention to the tri-jointed nature of his legs; look at photo references of goats or other hoofed animals if need be.

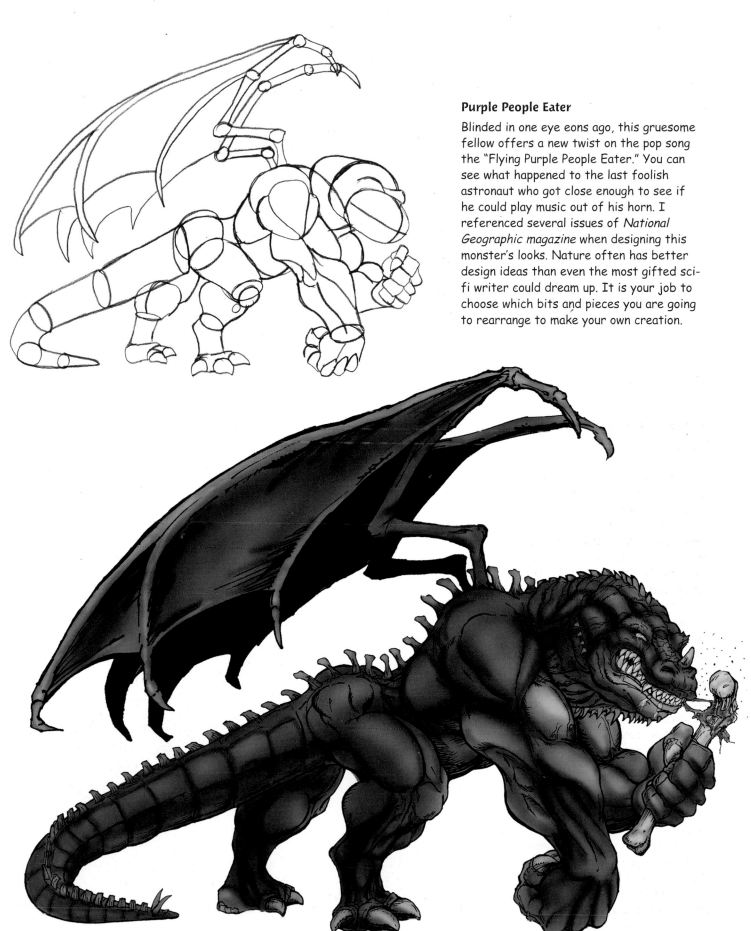

Purple People Eater

Blinded in one eye eons ago, this gruesome fellow offers a new twist on the pop song the "Flying Purple People Eater." You can see what happened to the last foolish astronaut who got close enough to see if he could play music out of his horn. I referenced several issues of *National Geographic magazine* when designing this monster's looks. Nature often has better design ideas than even the most gifted sci-fi writer could dream up. It is your job to choose which bits and pieces you are going to rearrange to make your own creation.

FEMMES FATALES

"Make Wife. From Dead."
—THE FRANKENSTEIN MONSTER,
Bride of Frankenstein (1935)

Witches

Witches and witchcraft are found in the myths and legends of almost every culture in the world. Among the many famous witches in fiction are the cannibal witch in "Hansel and Gretel," the Wicked Witch of the West in *The Wizard of Oz*, and the three hags in *Macbeth.* Not all witches are ugly old women. In the 1942 psychological thriller *Cat People* Irina, a beautiful woman who has come to New York from a village in Serbia, tells the story of a race of witches who were put to the sword by a Serbian king. She further relates that some of them escaped, and when one of the surviving witches was kissed by a would-be lover, she turned into a leopard and tore the unfortunate suitor to shreds.

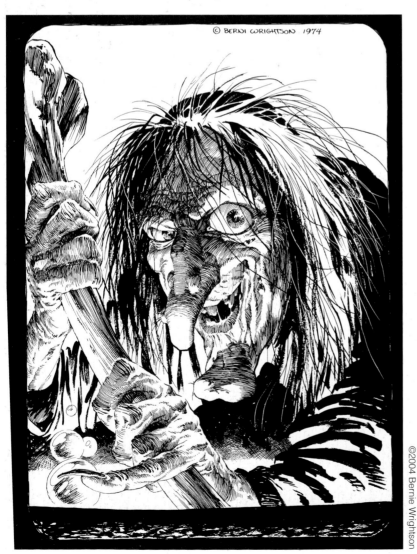

©2004 Bernie Wrightson

Wrightson Witch

The lighting on this horrifically ugly hag accentuates every hideous detail.

Gillady

In this variation on the gillman theme, artist Arthur Adams has created an intriguing cast of characters. Adams is not only a master artist but a master at creating scenes that make the viewer immediately want to know more. And that is what good illustration—in *every* genre—is all about.

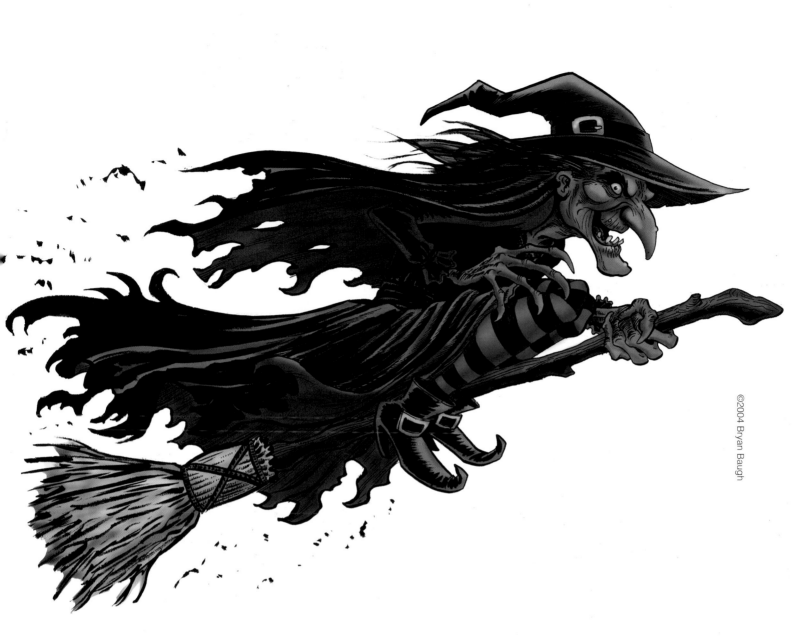

Classic Witch

She rides around on a flying broom. When she cooks up a stew, the ingredients include bugs, earthworms, eyes of newts, and the arms and legs of small children. When she's mad she turns people into toads and when she's happy she lets out a long, harsh cackling noise. Aren't little old ladies just the dearest things?

 For a pose like this to work, you're going to have to depart from the usual order of things. First draw the horizontal line of the broomstick so you know where the figure, in its crouched pose, will rest. Then draw a circle in the spot where you want the witch's pelvis to be, sitting atop the broomstick. Next draw a basic shape for the hand, in the position where it holds the broomstick. Now you can go ahead and draw the curve of the witch's spine, a basic shape indicating her head, and lines for the arms and legs. With that, you've got the important stuff nailed. Now you can have fun drawing the witch's scary face and fluttering clothes, as shown.

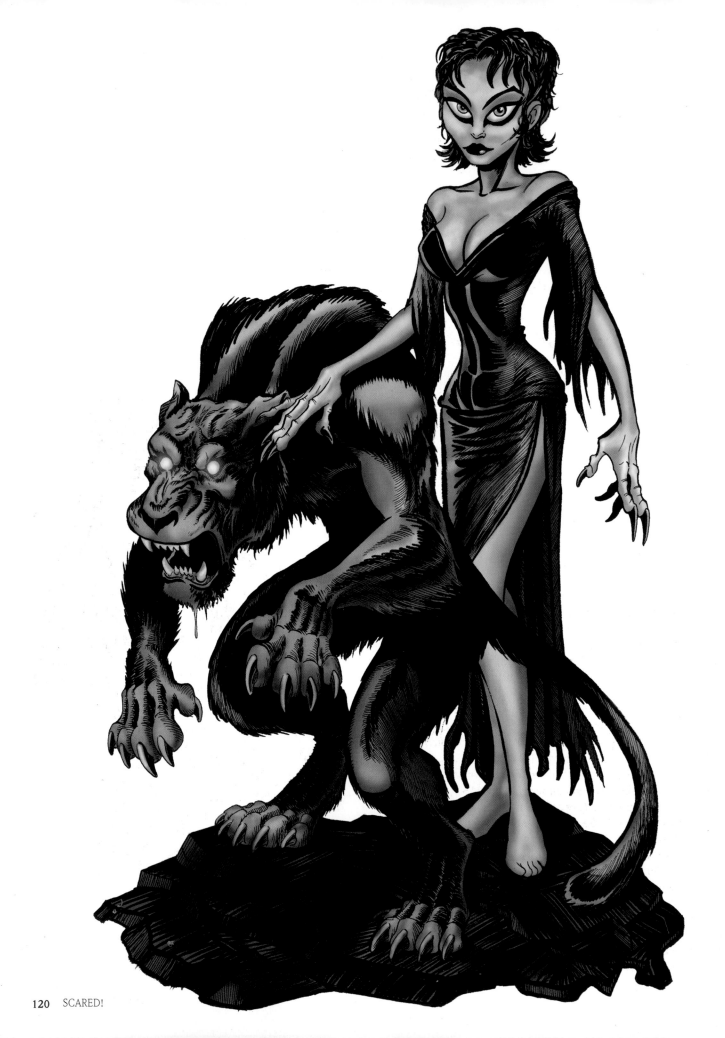

Cat Witch

If you are unlucky enough to be attracted to this shape-shifting witch and she in turn finds you a tasty morsel, beware. After the woman kisses, the panther kills. The challenge here is to show her appeal—both feline and feminine. A heart-shaped face, a pair of oversized, slanting eyes, a small nose, and pouting lips all evoke the cat spirit inside—not to mention those fingernail-claws. The monster next to her is also a witch, but in feline form. It is structured just like a normal, four-legged panther, except that it's standing on its hind legs and the arms are faintly human. The fun part of drawing these characters is texturing the fur and dress to make them look black and shimmering. To do this, first figure out where the highlights (areas of white) will go, and mark them off with a pencil. Second, fill in everything around those areas with black ink. Third, go into the white areas and "shade" them with thin, careful line work, so that there will be some gradation in tone from harsh black areas to harsh white areas. Remember, to get highlights (and shadows) right, you have to decide which direction the light is coming from. It can help to draw a small circle (with a pencil, so you can erase it later) off to the side of the character that represents the light source—sun, moon, lightbulb, whatever—so you'll be completely consistent.

Sea Witch

She sells evil spells by the sea spell shore. The sea witch lives by the ocean, so give her necklaces of shark's teeth and draw seaweed dangling off her shoulders and arms. Drawing this witch's dress is a fun exercise in creepy abstraction. Notice that in drawing her arms, the usual rule that you need to draw all body parts, even those that will be covered by clothes, was followed, but the legs were never sketched in. Getting the dress right is just a matter of using a pen or ink brush to make long, wiggling lines running down where her legs would be and spreading out when they reach the beach. Sometimes it's OK to break with realism completely. It doesn't make structural sense that the hag's dress lies about her feet in long, coiling, slithering lines like the tentacles of a dead octopus, but it looks creepy and weird, and it feels right for the character. Notice the linework on the face, creating texture that ups the ugly ante.

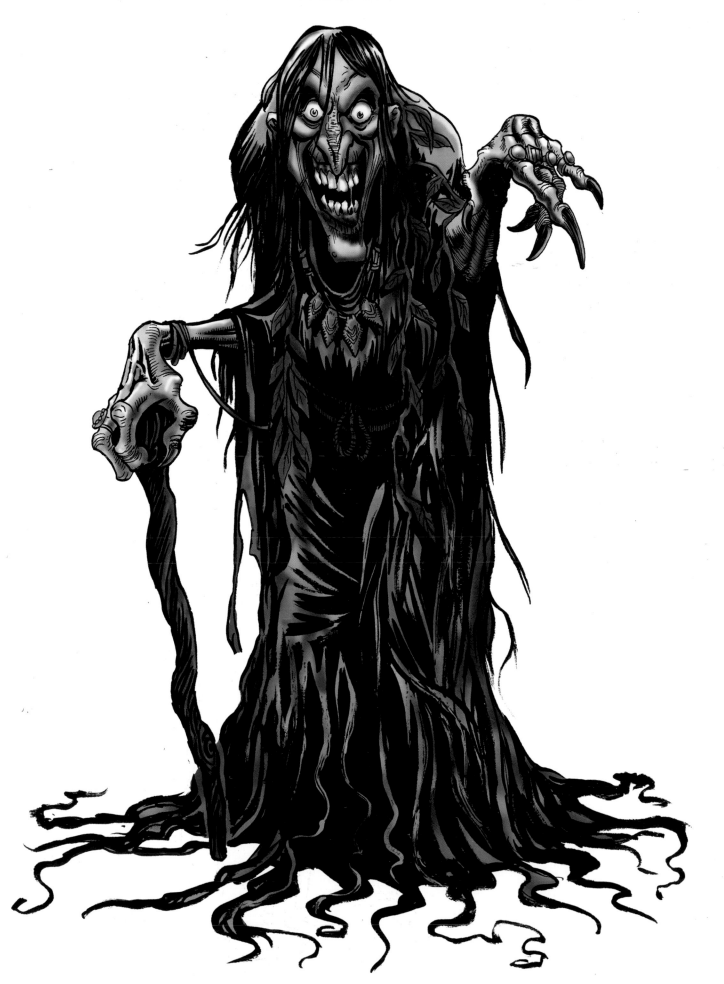

Two Female Monsters and Their Friends

Here are some fresh takes on female monsters drawn by comic book artist extraordinaire Arthur Adams.

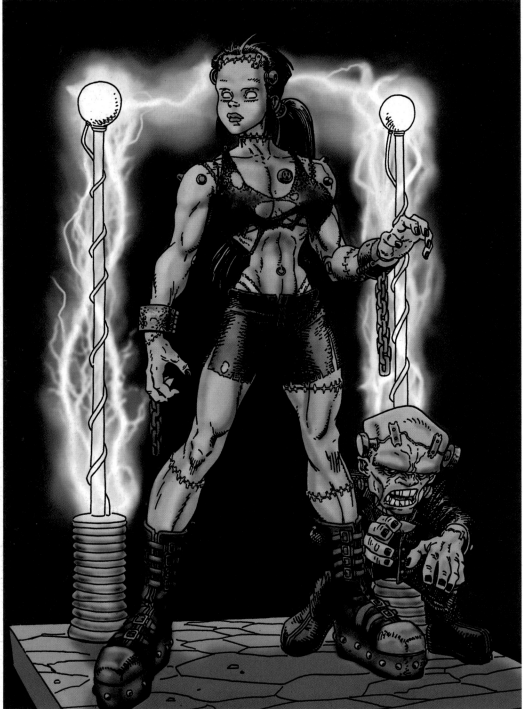

Adams's female Frankenstein's monster, like his female vampire , has a pint-sized sidekick. Sidekicks are a good source of comic relief. Humor, interestingly enough, often works to complement the scary scenes in successful horror fiction. Balancing suspense and terror with lighter moments can give the reader a more complete roller-coaster ride through the gamut of human emotions.

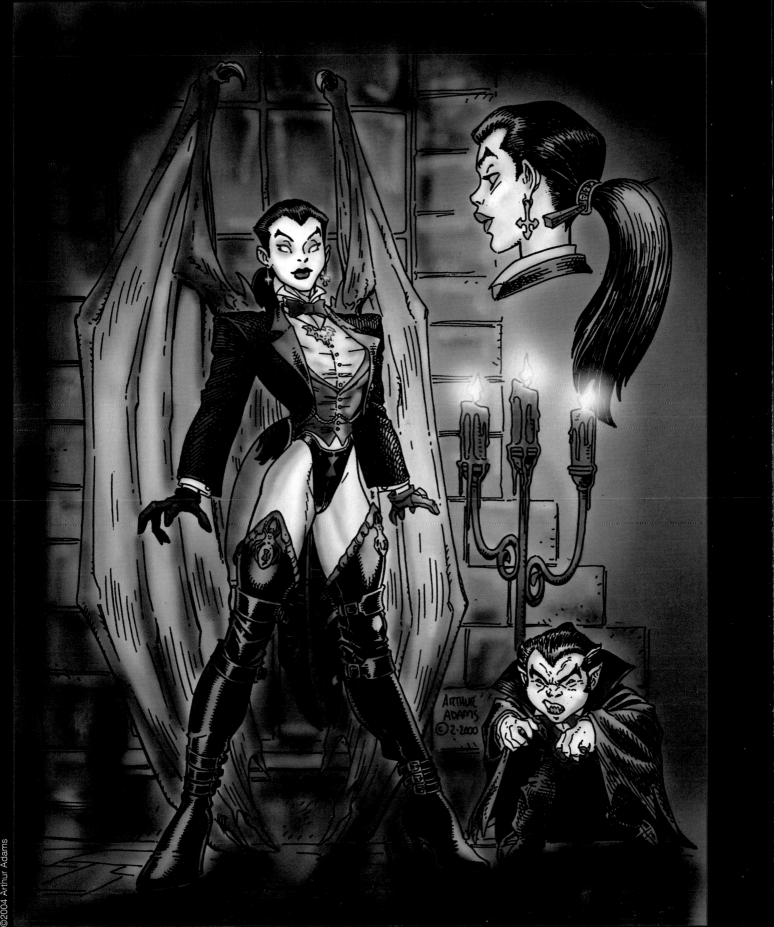

CREATURE FEATURES

"Lights! Camera! Kong!"
King Kong (1976)

We've pretty well covered human, once-human, inhuman, and extraterrestial monsters. In this chapter we turn to beasts. Remember, you can draw animals using the same basic system you use to draw people and monsters. You start every drawing as an elaborate stick figure, then build up the stick figure with simple shapes for all the major body parts. Once these are in place, you can start adding details, textures, and shading.

When it comes to drawing animals, what could be more fun than drawing a gorilla? Why drawing a giant gorilla of course! From Kong to Mighty Joe Young we sure love our gigantic simian movie stars. Certainly both of those films provide an extra dimension to the old man-against-nature plot anchor. Not only do we see human beings pitted against the raw, primal force of nature, we see nature, personified as beast, being victimized by that unfortunate by-product of civilization—crass commercialism. Throw a beautiful blonde into the mix and the story is irresistible.

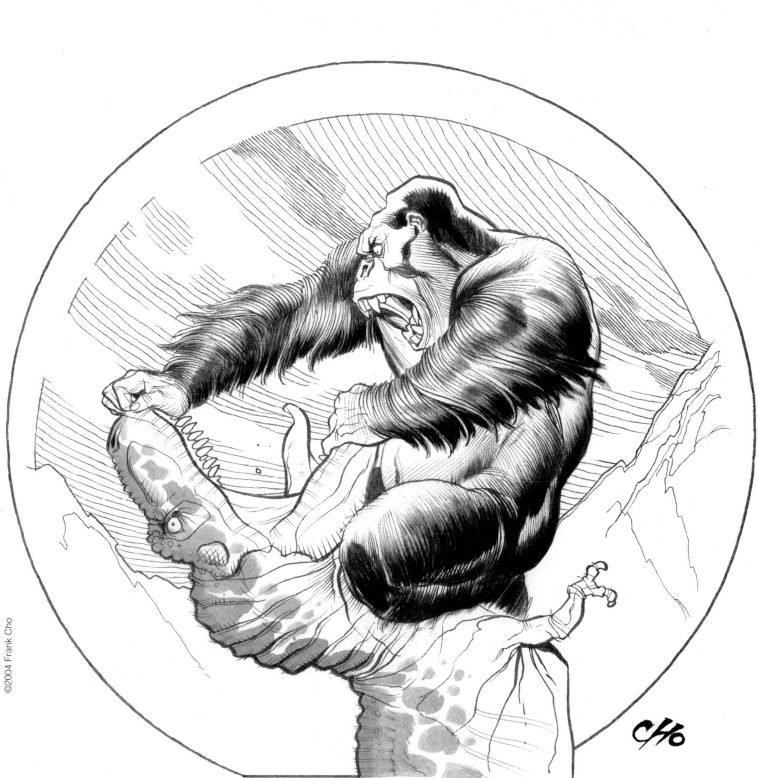

Pong vs. T-Rex

Of all the members of the animal kingdom the primates are most like human beings. When drawing this magnificent monkey remember to think in terms of human anatomy, just stronger, with longer arms, stouter, and a whole lot hairier.

Teddy

This ironically titled illustration is Bernie Wrightson's inventive take on the classic beast-versus-beauty horror theme.

Devil Dogs

Monstrous dogs are commonly used to guard haunted castles, the graves of vampires, and other evil places. I'm not sure what breed these guys are, but I'm pretty sure the American Kennel Club doesn't have papers on them. If you want to make any kind of animal look scary and evil, you have to know which features to accentuate. In the case of these canine devils, their eyes are left as blank orbs, conveying a cold, emotionless state of mind. The ears of the black hound have been elongated into tall, curving points, resembling horns.

©2004 Mitch Byrd

©2004 Bryan Baugh

Black Cat

If a black cat crosses your path, that's bad luck. If her owner is a wicked witch, that's really bad luck. If she is actually a wicked witch who has shape-shifted into a cat, that's really, really bad luck!! There are three main spherical parts to most quadruped's bodies. Use circles to rough out the placement of the head, the rib cage including the shoulders, and the hindquarters. The legs are cylindrical.

Scary Tree

This nightmarish tree would be a perfect perch for any of the feathered fiends on the next few pages.

Owl

An alternative to dense linework, noodling out every single feather in ultrafine detail, is to draw in a well-spaced scattering of lines to create just the subtle suggestion of feathers.

Carrion Crow

The feathers on this crow are even less like "real" feathers than the feathers on the owl, but they are, unmistakably, feathers.

Scary Scavenger

These large birds feed on rotting carcasses, a habit which makes them perfect symbols of death. The Grim Reaper is often shown with a pet vulture on his shoulder. Though ugly, these scavengers are marvels of aerodynamics. Vultures have weak talons and can only carry small portions of meat. This is why they make buffet lines around their food: a carcass is eaten wherever it died. Birds in general aren't terribly hard to draw. It's figuring out how to draw their feathers that gives a lot of people difficulty. No matter what type of bird you are drawing, it's a good idea to first look at some good photographs of the real thing to see how the patterns of long and short feathers are distributed on the bird's body. Map out the feather pattern at the pencil-sketch stage. (The curved lines drawn through the feather lines on the vulture sketch mark where the short feathers end.) Then, when you go to finish the drawing in ink, you can decide for yourself how much detail you want to put in.

Baaad Bat

Bats are small, flying rodents that like to hang-glide around haunted houses, graveyards, and other spooky places. If you see them, beware. Where there are bats, there are usually vampires close by. A bat's wings are structurally similar to a person's hands, so the rules for drawing hands also apply to bat wings. First draw the placement of the underlying bone structure, then connect "the fingers" with a thin elastic membrane for the wings.

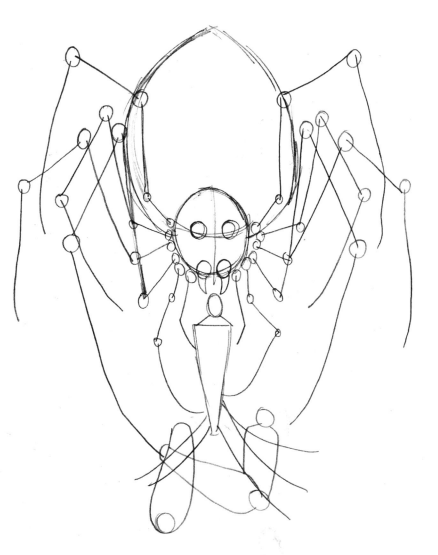

Arachnophobia

These babies are way too big to settle for flies! We know, we know, all those legs look very hard to draw. If you first sketch in all eight legs, even the ones that will be partially hidden, you won't go wrong later.

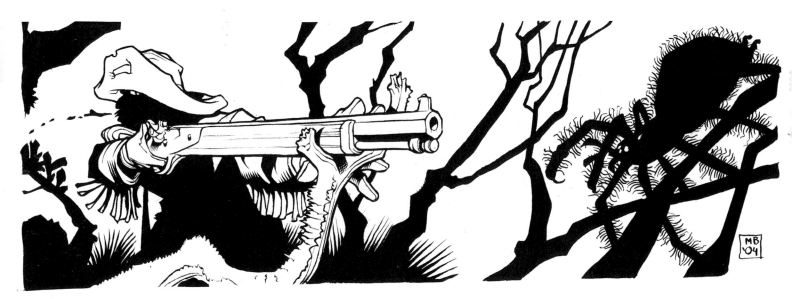

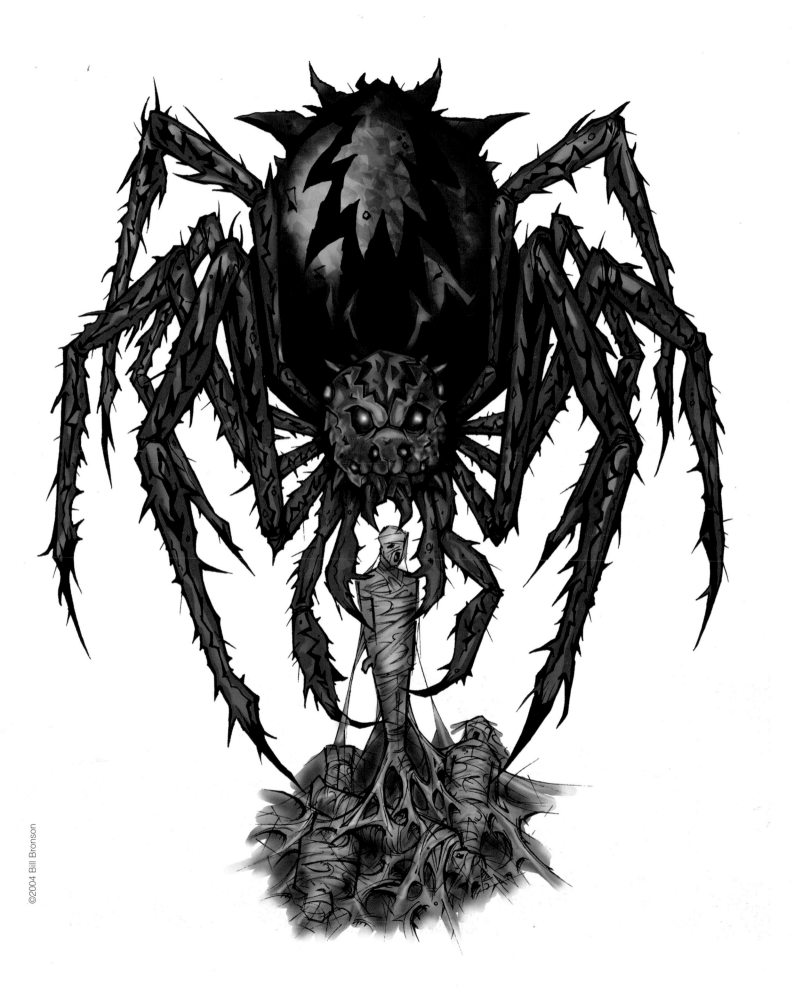

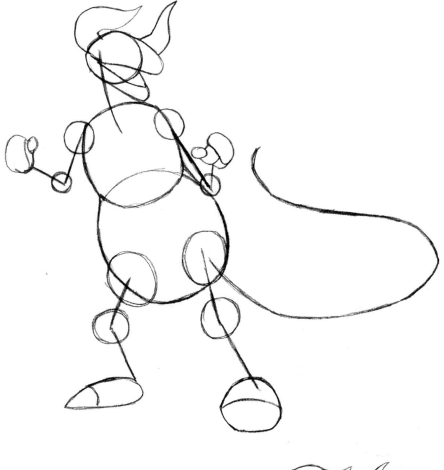

King Mecha-Daikaiju-X-osaurus

Kaiju, the Japanese term for monster, also refers to a specific *type* of monster seen in Japanese films. It's more accurate to call this kaiju-like Godzilla *daikaiju*, or giant monster. When drawing this guy start with a pear shape for the body. The limbs and tail are based on cylinder shapes. If you want your character to have the classic daikaiju look, practice drawing a human figure inside his chest to get that old "Man in a Monster Suit" characteristic.

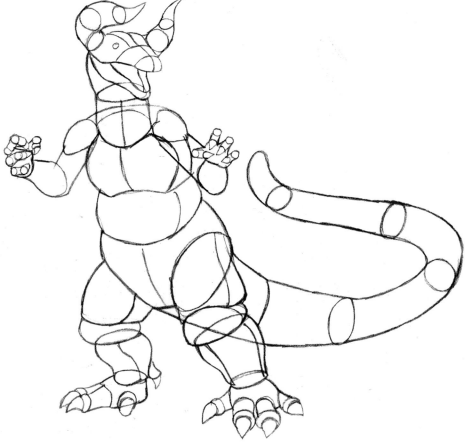

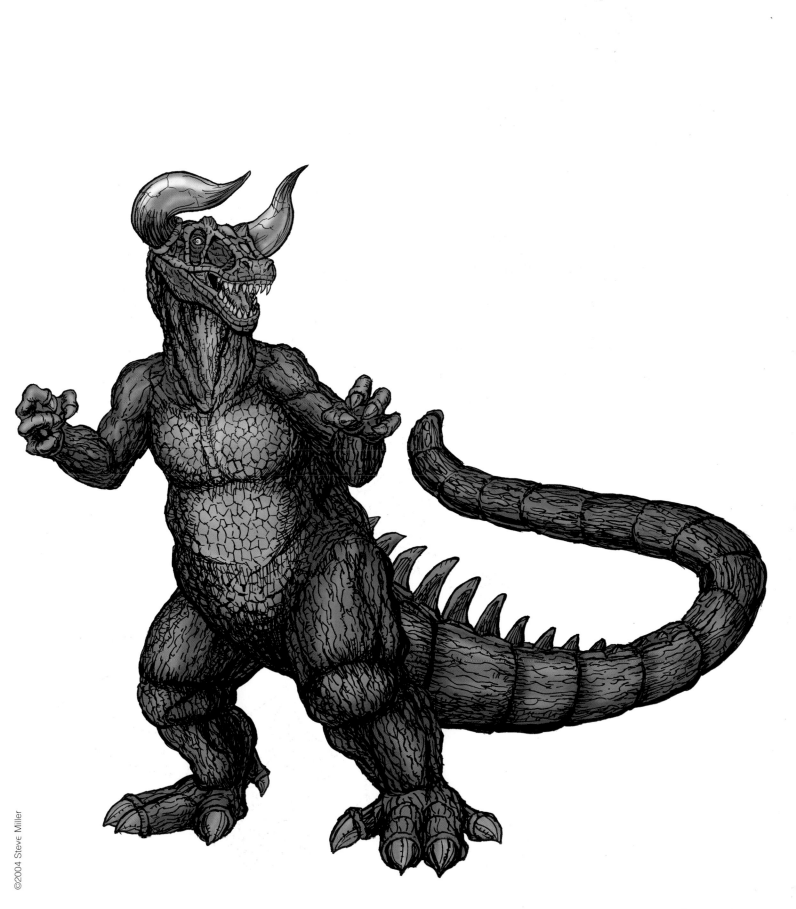

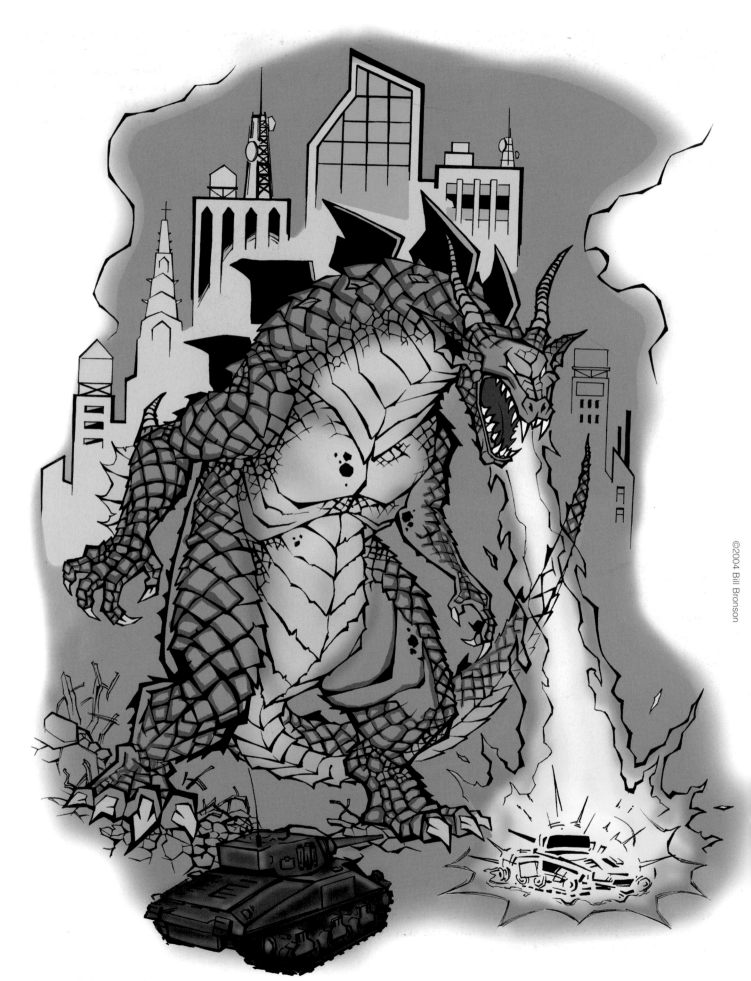

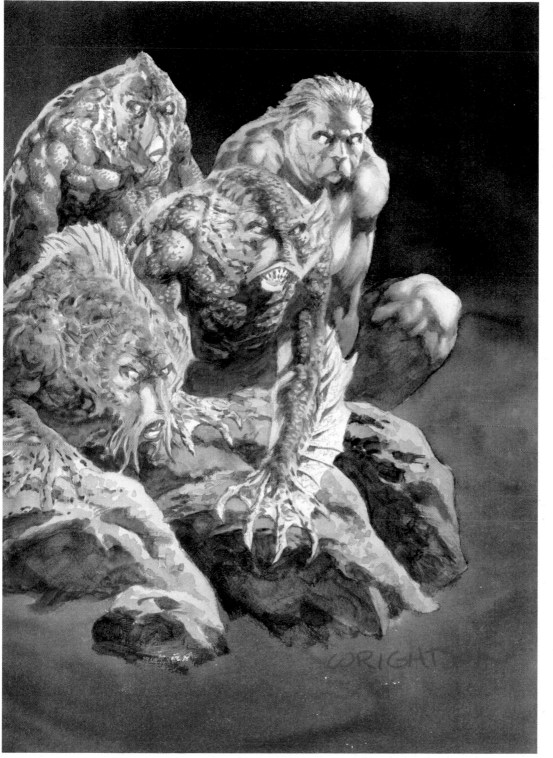

Amphibious Assault Again

Bernie Wrightson's interpretation of the humanoid fish-monsters from H. P. Lovecraft's classic story *The Shadow over Innsmouth.*

Giant Monster

It's hard to take a stroll downtown when you're as big as a skyscraper and your favorite food is people. You're just asking for a fight. Obviously, giant monsters will require a different sort of approach than the usual human stick figures. This guy is built more like a snowman with a long neck. Use a series of circles, ovals, and cylinders to build his basic framework, just as you did for the monster on the previous page. Then add in all the fun details.

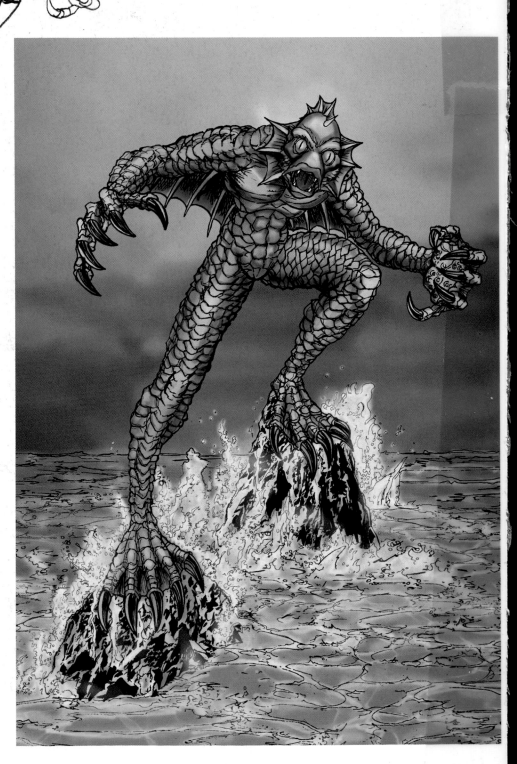

Gillman

Holy mackerel! Why'd we put a fish monster in this book? Oh, just for the halibut. He came into the office looking for a job and said, "I'm willing to work for scale."

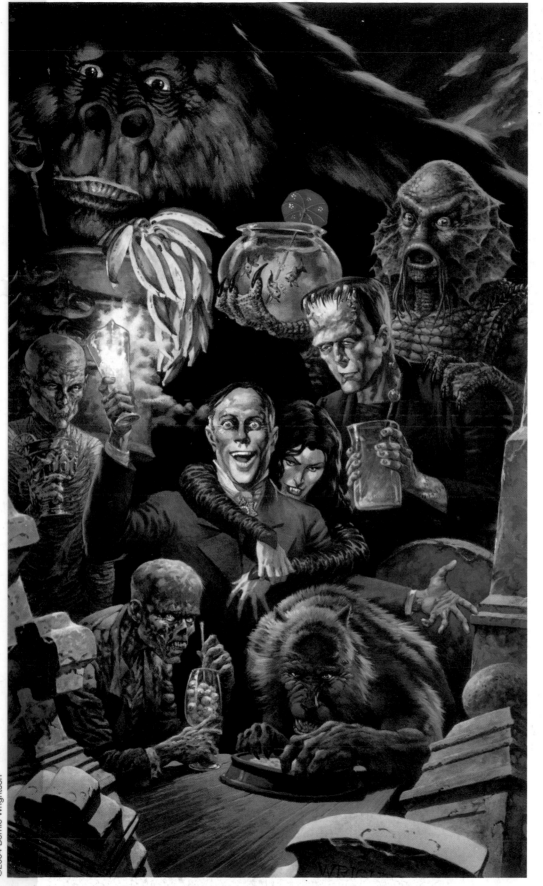

©2004 Bernie Wrightson

Zacherley and Friends

Bernie Wrightson's wry sense of humor can be seen in many details in this picture, including the goodies the monsters have brought for their potluck "Dinner with Zach" and the very large gorilla in the background. Zach (born John Zacherle in 1918) is no longer seen on TV, but horror fans may remember that in 1982 a *Fangoria* draft-Zacherle campaign landed him a spot as host on WOR-TV's *Gorilla at Large.*

INDEX

Page numbers in boldface refer to illlustrations